CAPE LIGHT: COLOR PHOTOGRAPHS BY JOEL MEYEROWITZ

CAPE LIGHT

COLOR PHOTOGRAPHS BY JOEL MEYEROWITZ

FOREWORD BY CLIFFORD S. ACKLEY INTERVIEW BY BRUCE K. MacDONALD

MUSEUM OF FINE ARTS, BOSTON

A NEW YORK GRAPHIC SOCIETY BOOK / LITTLE, BROWN AND COMPANY, BOSTON

Fourth printing, 1985
Copyright © 1978 by Museum of Fine Arts, Boston
Library of Congress catalog card no. 78-13869
ISBN 0-87846-131-0 (paper) 0-87846-132-9 (cloth)
Typeset by Wrightson Typographers, Newton, Massachusetts
Printed by Acme Printing Company, Medford, Massachusetts
Designed by Carl Zahn

This project is supported in part by a grant
from the National Endowment for the Arts,
a Federal Agency

Also by Joel Meyerowitz
ST. LOUIS & THE ARCH
WILD FLOWERS

New York Graphic Society books are published by Little, Brown and Company.
Published simultaneously in Canada by Little, Brown and Company (Canada) Limited.

FOREWORD

In the last few years there has been a noticeable acceleration of activity in the field of expressive still photography in color. During this period a number of contemporary American photographers have shifted from working in black and white to working partly or exclusively in color. One of the photographers who has most successfully made the transition from seeing in terms of black-and-white tonalities to seeing wholly in terms of color is Joel Meyerowitz.

The color work shown here, shot on the Cape in the Truro-Provincetown area during the summers of 1976 and 1977 with an 8″ x 10″ view camera, is characterized by an unusual subtlety and refinement of color, by a photographic vision that focuses on the color of light and atmosphere rather than brightly colored objects or "local" color. The large-format negatives and their sensitive contact (same size) printing by the photographer insure not only the maximum intensity of documentary detail but also that the finest nuances of color are recorded. These subtler passages are often fully experienced only upon a second or third reading of the photographic print.

Meyerowitz's earlier work is part of a modern tradition of "street" photography in which Cartier-Bresson and Robert Frank are central figures. This black-and-white work, made with a small (35-mm) hand-held camera, involves lightning-fast decisions, which result in images characterized by unusual angles of vision, strong graphic patterns, surprising juxtapositions, and a lively feeling for irony and wit. The photographer's openness to happy finds, a lesson learned on urban streets, often lends a sense of energy and visual playfulness to the quieter images made on the Cape.

The Cape Cod view camera pictures are serene, contemplative, characterized by a new stability directly related to the use of a new instrument, the heavy Deardorff view camera, with its fixed tripod and its ground glass inscribed with a precisely ruled rectilinear grid.

Many of these images have a frankly poetic or romantic flavor rather than the cooler, more ironic distance often experienced in the urban work. This is most readily seen in the group of twilight pictures in which Meyerowitz explores the poetry and mystery of the time of day that the French call *entre chien et loup* ("between dog and wolf"), an expression that has a strong appeal for the photographer.

Meyerowitz is intensely conscious of working within a tradition of American artists who have recorded with purity and clarity their feelings about the Cape, its structures and its light: artists such as Edward Hopper and Milton Avery. Meyerowitz's profound attention to the light and atmosphere of the Cape is most clearly expressed in two series: the "Bay/Sky" pictures, in which the same view is recorded in different temperatures of light and weather, and the "Provincetown Porch" pictures, in which a variety of moods and vistas are discovered from the porch of a seaside house in the course of a summer's residence. The two series maintain a wonderfully expressive equilibrium between accuracy of observation and intensity of feeling.

One of the pleasures of repeated viewing of Meyerowitz's color view camera pictures is the way in which their heightened objectivity serves to intensify our experience of color in the world around us. Our nervous, shifting vision tends to be highly selective, related more to identification and information than to aesthetic contemplation.

We rarely experience the total context of color, the color of light itself, as we can when Meyerowitz isolates and preserves the colors of the moment in the frame of his camera.

Three years ago when I first visited Joel Meyerowitz to look at his black-and-white work, he showed me 35-mm color work that I found to be of equal interest. A year later when I saw the first Cape Cod view camera pictures, I responded to the new sensitivity to color this work displayed and sensed an opportunity to introduce the museum's public to some of the issues raised by expressive contemporary photographic work in color. The ninety-five images for exhibition were selected in collaboration with Joel over a two-year period. From the beginning we worked closely with Carl Zahn, the museum's designer and editor-in-chief of publications, on plans for the book of the exhibition. Joel selected and sequenced the images for the publication with our approval. The title is his.

We are deeply indebted to Bruce K. MacDonald, dean of the Museum School, a good friend of the photographer and a practicing photographer himself, for the conversational interview with Meyerowitz that prefaces this publication. This conversation illuminates the photographer's picture-making process and the emotions that accompany it. Joel is responsible for the informative note on technique and the biographical information.

I would like to thank the members of the Department of Prints, Drawings, and Photographs, Eleanor Sayre, curator, for their continual support. To Sue Reed of that department, who provided valuable assistance throughout the project, I am particularly indebted. We would like to thank the Department of Contemporary Art, Kenworth Moffett, curator, for providing the space for the exhibition.

The exhibition and catalogue have been supported by a grant from the National Endowment for the Arts, and the photographer's work on Cape Cod during the summer of 1976 was supported by a CAPS grant from the New York State Council on the Arts.

Joel would like to express his gratitude to his friend Murray Reich, who first encouraged him to discover the beauty of the Cape. He also wishes to thank Joanne Mulberg, who assisted him in the printing of the large body of work from which his exhibition was selected. Further thanks are extended to the Witkin Gallery, New York, for their cooperation and to K. & L. Laboratories, New York, for providing the fine enlargements for the installation. And, finally, I would like to thank the photographer's family, Vivian, Sasha, and Ariel, for their patience during the preparations for the exhibition and publication.

CLIFFORD S. ACKLEY, *Associate Curator,* Department of Prints, Drawings, and Photographs
and curator for the exhibition

will see it and feel the jolt as it crosses your vision and your awareness. He doesn't have to *hold* on something for a great period of time for it to register. He doesn't have to pummel you with what you see. He can just tantalize you with it, pass it in front of you, make you feel it. And I saw that, instead of making a picture of *it,* you can turn away from it and photograph something nearby, and *include* that in it, not making it the central subject of the picture. You can see what's happening around it and, by its energy, it will draw people to looking at it. I was willing to take the risk. I wanted to make the frame alive—a place where you have to search to see.

Photographers deal with things that are always disappearing. We're on the edge of knowing, and then only by a shred of feeling of almost no duration. The desperation is to find the form, the appropriate form for what you're photographing, what you're interested in, wherever you are! On the streets the search for the form is what drives me. Here on the Cape the need is the same, but I'm using a different tool.

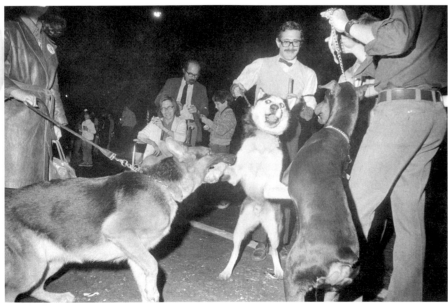

New York City, 1971

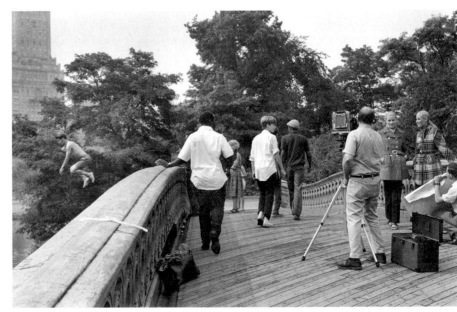

New York City, 1969

radio programs were part of ours; they left us hanging. I have a similar feeling about the episodic quality of my street photographs. They reflect a picaresque adventure that's unfolding for me. I go out with no expectations. I go out to be *in the place* that I'm in and to be as fully committed to being open to it as I can be, with no prejudgments or preconceptions of what I'm going to find. I photograph to see what I'm interested in.

JULY 22, ON THE DECK

MACDONALD: I've watched you work. Sometimes with a small camera you work so fast that you can't entirely understand the situation in front of you, and the people being photographed don't have time to react to the camera. You don't bruise the situation.

MEYEROWITZ: The fact that the machine works at a 1000th of a second allows you to gesture at things radically, even before you know them. You use the speed of the camera as a property. If you've got 1000th of a second, then you should *use* it and see what it's like to work in that zone of high speed—which means you can release yourself in a gestural way at a 1000th of a second. Sometimes I literally plunge into it, throw my whole body into the subject, the crowd moves away, and people spill into the frame from the other side. I move the image off center, somehow turn away. I want to engage something that's only peripheral in my eye. I fill the frame. And then when I get the picture back, I get what a full-blown gesture at a 1000th of a second sees.

MACDONALD: What do you mean by turn away?

MEYEROWITZ: I felt that most of street photography coming out of Cartier-Bresson was aimed at locating an event in space with the camera, and singling it out, sometimes pointing at it by juxtaposing it to something else. But you know exactly what it is that's being photographed. You know what the intention and the accomplishment of the photographer is. After years of doing that and getting faster at that kind of location, I began to feel like a visual athlete—making sensational catches, but having less to learn from. The more in touch I became with what I personally was interested in, the more I wanted to loosen up the frame. I had a sense of desperation.

About that same time when I was coming to consciousness—this was in the sixties—Fellini was my hero. Fellini taught me something else—a kind of organized chaos—his willingness to see *everything* come in front of the lens, to give it a certain amount of time and then turn away from it. That's the turning away I learned about. Just think about the elaborate preparations he goes through to set up certain scenes—filled with grotesques, filled with motion, people moving toward and away from the camera. As they come by, he just makes a pass, and they're off the screen in a split second. He wastes them. He knows, and trusts, that you

MACDONALD: Where did you find the confidence to experience your feelings in the street and to make pictures there? How did it start?

MEYEROWITZ: My father's a natural comic. He played in vaudeville, imitating Chaplin; he was also a boxer. Very fast with his hands—he's a small man with a lot of those small man's needs about protecting yourself. At an early age he taught me to box—took me down to the basement, showed me how to punch the bag, made me put my "dukes up," taught me some lessons of the street—taught me to *watch*. He said to me, "You ever get in a fight, keep your eyes open, most street fighters are going to *telegraph* what it is they're going to do, 'cause they don't know how to box. There's no art. They're going to flare with their hands." He said, "You protect your head, feint with your body, and when they drop their guard—boom! knock 'em down." It was true, growing up in the Bronx where there were street gangs and the like, you had to know these things. If he hadn't told me then, I wouldn't have known what to do, and I would have run all my life. This way I understood the street. I could take care of myself, maybe take a licking here and there, but I knew from my father that things would be all right. It's always good to have a model like that. Imagine—knowing that they were going to tell me what they were going to do—isn't that terrific!

I lived in a ground-floor apartment, so watching the street was great entertainment. After all, the whole of street life in the neighborhoods was based on strut and gesture. Everybody wanted to be a comic or a hero or a tough guy. Remember what happened when somebody walked by with what used to be called an "affliction"? There was always one guy who peeled off out of the crowd and walked up the street doing a crazy imitation, turning around over his shoulder, showing off to the gang, like Huntz Hall to Leo Gorcey and the Dead-End Kids. There is a point-counter-point with street humor. I saw it in the Marx Brothers with their glances, imitations, and double takes all the time. I loved that. What comes to mind now is that I remember my father telling me about people telegraphing and how to feint and dodge and move with them. I feel that's what street shooting is like. Street photography, the kind that I practice, is about reading the signals that people are sending. I play with that. I have a feeling that part of my sense of humor, my timing, my attitude on the street was formed by watching those movies and learning those basic words of awareness from my father.

MACDONALD: What other influences come from childhood?

MEYEROWITZ: The way you perceive the world. My sense of time. Think about the serialized imagery in comic books, the way things continue from box to box. Those weren't paintings that were stated whole in one frame. Every generation has a different resource. Serialized movies and

A CONVERSATION: BRUCE K. MACDONALD WITH JOEL MEYEROWITZ, JULY 22–26, 1977

I was asked to write an essay for this catalogue, and I declined in favor of Joel. He speaks clearly and passionately about art in general and his own work in particular. We agreed upon a tape-recorded conversation about his work. It took place in and around his rented beach-front cottage in Provincetown during July 1977. In a subsequent note describing the edited typescript he wrote, "This was a rambling, fitful dialogue that sputtered and sparked over a five-day period in July. Woven into it, but invisible here, were children's interruptions, swims, meals, and shooting excursions. Questions hung fire and caught on again, sometimes days later. We had one goal—to get *close!"*

From my perspective our task was straightforward: to help viewers sense and appreciate the extraordinary depth and purity of feeling recorded in these deceptively simple and beautiful photographs of Cape Cod. The interview was five days of pleasure. We reviewed old friendships, came to terms with language, and began to trust our communication. Joel was ready to talk about his work. Words came easily but sometimes carried, dragged, or pushed their meanings at odd angles, if with extraordinary eloquence. As the conversation took shape, it created its own possibilities. We felt the opportunity to engage the personal feelings that support Joel's work. We pursued this course rather than a more traditional interview format. During the months that followed, our tapes were translated into more than one hundred pages of typescript. We took license to rearrange and reshape these pages until only twenty-three remained.

Joel's earliest work displayed virtuoso dexterity. It began in black and white about fifteen years ago with a 35-mm camera on urban streets, especially in New York City. This recent, more stately work was made with an 8″ × 10″ Deardorff camera in color on Cape Cod. All of his work is characterized by a balance of craft and feeling. Craft includes deft manipulation of camera and darkroom equipment, interaction with subjects, and aesthetic judgments about shape, color, picture edge, sequence, and all of the other aspects of seeing photographically. Feeling is the emotional response to experience. I often sense that Joel has the courage or fearlessness to allow the sensation of experience, especially visual experience, to flow through him at much higher amperage than most of us. As these feelings have become more mature and refined he has responded to increasingly subtle and majestic triggering stimuli with his camera. The drama of the street has given way here to the play of light as it carries information about color and texture through the lens of eye and camera. He has become so sensitive that vision itself is now his subject.

BRUCE K. MACDONALD

JULY 23, ON THE PORCH, DURING LUNCH

MACDONALD: Why are you using color?

MEYEROWITZ: Because it describes more things.

MACDONALD: You're used to working with a small camera. Why is it that you're working with color and an 8″ x 10″ view camera here on Cape Cod?

MEYEROWITZ: There's a logic to all of this, an internal logic, almost a command.

MACDONALD: How so?

MEYEROWITZ: When I committed myself to color exclusively, it was a response to a greater need for description.

MACDONALD: What do you mean by description?

MEYEROWITZ: When I say description, I don't only mean mere fact and the cold accounting of things in the frame. I really mean the *sensation* I get from things—their surface and color—my memory of them in other conditions as well as their connotative qualities. Color plays itself out along a richer band of feelings—more wavelengths, more radiance, more sensation.

I wanted to see more and experience more feelings from a photograph, and I wanted bigger images that would describe things more fully, more cohesively. Slow-speed color film provided that.

MACDONALD: Are you talking about the small camera or the big camera?

MEYEROWITZ: It was the 35-mm, although with a growing understanding of the materials and the logic of process, if you will, I arrived at the 8″ x 10″. It seems to me that my strongest desires are to tell, to tell fully, roundly, sometimes too much. The Cape seemed the right place to begin. It's so different—so opposite from the street. The work I did last summer taught me a lot. I felt there was even more here.

MACDONALD: What do you hope for when you say the work teaches you?

MEYEROWITZ: Well, you hope that by working—working out, working toward that—you'll produce an opening, you'll stumble through your senses upon a photograph that's instructive—a doorway—something more than just beautiful, or well-made, or a combination of those elements that are photographically interesting—something that you can't quite handle that possesses you, something simple and visible but filled with mystery and promise—the mystery of "How did I *know* to make that?"—and the promise of a new understanding of photography and something about yourself.

These photographs are often the least beautiful: spare, sometimes empty of qualities that are more easily celebrated. One makes the other photographs on the way to these rare, irresistible images that claim your deepest attention. The trick is not to be seduced by the beautiful but to struggle *against* accomplishment and push toward something more personal. Shared beauty is not enough. One wants to go beyond those limits, not for the sake of invention, but for knowing.

MACDONALD: The Cape is beautiful. Provincetown is beautiful. This porch on the edge of the sea is beautiful. Given an almost infinite number of possibilities, what is it that brings you to one spot rather than another? How do you arrive at feeling that *this* will make a photograph?

MEYEROWITZ: The thing itself. The place itself. You walk into the place and that's it. It is *other*. The place resonates a quality that you respond to. You feel your *self* in relation to its otherness. It's like the infinity sign—the distance is so great it comes back on itself. At a given moment it's the way the light caresses the buildings, the way the chip of the horizon appears in the alleyway; it's the waving of the grass; it's the snap of a curtain. It's *everything*. It's one *whole*. At that moment, you step past, into that whole, and it swallows you up.

I sometimes am standing in front of something so entranced that I almost forget to take the picture until I try to tear myself away. It's at that breakaway moment, when I want to move on with the camera, that I realize, "Stay! You're being spoken to—answer!"

In the last few months my level of awareness has been raised by the cumulative experience of having made these pictures last summer and coming back to the same place this summer. I feel I'm more finely tuned than I was last time. When the chord is struck, it's clearer to me. It's as though you come into a zone that is vibrating. You feel that *here* photographs can be made. You're ready. Your senses begin to separate the things in front of you. You feel, work, and play at the same time.

MACDONALD: What is the difference between light in black and white and light in color photography? Do you relate differently to the light?

MEYEROWITZ: The fact is that color film appears to be responsive to the full spectrum of visible light while black and white reduces the spectrum to a very narrow wavelength. This stimulates in the user of each material a different set of responses. A color photograph gives you a chance to study and remember how things look and feel in color. It enables you to have feelings along the full wavelength of the spectrum, to retrieve emotions that were perhaps bred in you from infancy—from the warmth and pinkness of your mother's breast, the loving brown of your puppy's face, and the friendly yellow of your pudding. Color is always part of experience. Grass is green, not gray; flesh is color, not gray. Black and white is a very cultivated response.

MACDONALD: What you're saying is that black and white translates light from all of the hues into tone, and there is no way to tell the light reflected from a red from the light reflected from a black?

MEYEROWITZ: Close. It expresses light as a matter of intensity. There's no meaning attached to the light.

MACDONALD: Black-and-white photography translates color into form, whereas color photography can convey significance from the very roots of the act of vision itself, from a place where you respond to primal kinds of things—colors, textures, sensations. What does that do for you, the sense that you can deal now with all of those primary responses about color?

MEYEROWITZ: It makes everything more interesting. Color suggests more things to look at, new subjects for me. Color suggests that light itself is a subject. In that sense, the work here on the Cape is about light. Look. Black and white taught me about a lot of interesting things: life in the streets, crazy behavior in America, shooting out of a car. Black and white shows how things look when they're stripped of their color. We've accepted that that's the way things are in a photograph for a long time because that's all we could get. That's changed now. We have color and it tells us more. There's more content! The form for the content is more complex, more interesting to work with.

After all, we're conditioned to respond to color. We're not narrow-wavelength beings. We're not dogs, which don't see certain colors. When we look at photographs that are in color, it's like looking at the world. Things in color mean something to us. Maybe we can't even verbalize what they mean. But as I look out this doorway right now, I encounter a black door—quite beautiful, that door—against a gray screen, against green trees, against a silvery sky, right now against that blue rug on that amber floor. My mind's eye trips as I plunge through that space.

JULY 23, LOOKING AT PHOTOGRAPHS

MACDONALD: There is a sense in which, looking at these photographs, knowing your former work, I've had a feeling that less is more. These are photographs of very little: a doorway, a window, a tree, a beach, a lifeguard stand, a picket fence, a field. As a black and white photographer you wouldn't have stopped in those places. I used to look at your other photographs and instantly see what they were. I look at these photographs for a long time and I feel more. Not because I am searching for a meaning, but because there's so much in them to see. What am I looking at? Am I looking at juxtaposition of colors? Am I looking at the way things translate into a photograph? I am seeing something I never saw before. I don't always know exactly what it is, but it has been refined into something very pure—a pure act of vision about how true colors relate to each other, about how each color had meaning in their former life. You

bring them together, and they relate to each other in some way. Talk to that. Less becomes more because these photographs are in color. In some sense, now, they become sublime.

MEYEROWITZ: What are we all trying to get to in the making of anything? We're trying to get to ourselves. What I want is more of my feelings and less of my thoughts. I want to be clear. I see the photograph as a chip of experience itself. It exists in the world. It is not a comment on the world. In a photograph you don't look *for,* you look *at!* It's close to the thing itself. It's like an excitation. I want the experience that I am sensitive to to pass *back* into the world, fixed by chemistry and light to be reexamined. That's what all photographs are about—looking at things *hard.* I want to find an instrument with the fidelity of its own technology to carry my feelings in a true, clear, and simple way. That's how I want to think about less is more.

MACDONALD: As I look at the photographs, there's a kind of tension because when I first look at them I see gas stations and houses and rubber rafts and things that I think I've seen before. But as I continue to look at them, I suddenly realize that I have never seen anything like this before, that, in fact, my eye is probably incapable of seeing something like this. And there's a kind of tension between recognition and the totally unfamiliar, in terms of the visual process itself.

MEYEROWITZ: John Szarkowski has used the expression "nominal subject matter." I think that's perfect for my behavior here. I'm not really interested in gas stations or anything about gas stations. This happens to be an excuse for *seeing.* Look at this (fig. 1 and pl. 13). Upside down, which is how I see it in the camera, this was the most wonderful skating pond I've ever seen, filled with the rippling effect of this fluorescent light zigzagging across this crimped aluminum, pitted against the gold of the sky, restated again in the upsidedownness of those lanes on the ceiling of that building, seen now as another floor. This whole inversion was exciting. I don't care if it was a gas station or if this is a rubber raft or if this is a crappy little house. *That's not* my subject! This gas station isn't my subject. It's an excuse for a place to make a photograph. It's a place to stop and to be dazzled by. It's the quantity of information that's been revealed by the placement of these things together, by my happening to pass at that given moment when the sky turned orange and this thing turned green. It gives me a *theater* to act in for a few moments, to have perceptions in. Why is it that the best poetry comes out of the most ordinary circumstances? You don't have to have extreme beauty to write beautifully. You don't have to have grand subject matter. I *don't need the Parthenon.* This little dinky bungalow is my Parthenon. It has scale; it has color; it has presence; it is real: I'm not trying to work with grandeur. I'm trying to work with ordinariness. I'm trying to find what spirits me away. Ordinary things.

Last year, on the first night I was here, I saw that raft against the side of the building (fig. 2). I caught my breath when I saw it. "Oh, that blue!" I didn't say "Look at the blue raft." I saw pure

color. I saw the blueness itself. It was radiant. It had depth. It had everything that I might possibly compress in my whole being about blue. It was only blue that was there. There are three pictures that have that blue in them—different photographs all. The same *thing* is in them. But in each one of them the blue is a different kind of notation. It got louder in the one where it's biggest and close. But I also put it back, and I pitted it against night—put it in its place against large blue so that there was a kind of dialogue between the two (see pl. 29). It was never a rubber raft to me—never! It was never a piece of American kitsch. It was never a little social comment on a bungalow with American junk. It was always about the purity of the thing.

What did I say when I drove by those bungalows—something about the lives lived in them?

MACDONALD: They had a kind of vitality themselves.

MEYEROWITZ: There was some sort of sadness, knowing what went on in them. But not in a social way, in a way that gave them that life. Every life that passed through there filled up the floor boards, the siding, with its history. You could feel it as you drove by. Those little bungalows had that feeling for me. Triangular boxes of sensations, boxes of memories. It's poignant. That little doorway with this piece of blue resting against it is poignant. I'm sure that Edward Hopper, painting here on the Cape, saw things revealed in this light with that same kind of poignancy because they're painted so lovingly! His subjects are small, nominal subjects. But the feelings are large and have a lasting quality to them, which is why they speak so clearly, without sentiment.

MACDONALD: That's a perfect description of the world you see.

MEYEROWITZ: But you always look to see if somebody else knew that too and if you're really close to the source. The thing I loved as I was growing up as a photographer was that I would make pictures out of my own instincts and print them, and then I would be looking through a book, say, of Cartier-Bresson, and I would see some work that I never saw before, and there would be a picture made the same way. And I would think, "Ah, we responded to the same kind of thing." There was some equivalent there—those things were worthy, and they were speaking a photographic language that tuning forks will vibrate to—if you go along with that idea that we're tuning forks and we respond when we're struck, always making the same note, the pure note. So, it would be the most pleasing thing to me to come across, through all of history, other photographers restating the same pictures—the same kind of picture, the same feeling.

MACDONALD: What made you make this picture? (fig. 3)

MEYEROWITZ: I drove by that last summer. And every time I drove by, I'd say, "Ah, that's beautiful."

MACDONALD: A line full of clothespins?

MEYEROWITZ: Yes. A line full of clothespins. I would see it from the highway and I would always remember to take a look at it; I never thought of taking a picture of it. As you drive along, all these little cottages sit between the highway and the bay, and the spaces between them set up a kind of rhythm all the way along. Then there would be a little pause, and you'd see this image that was sort of the diminutive of all the little buildings; it really is a surrogate seascape. It's exactly like the houses and the birds and the people walking on the flats here, when they're so small. One day, at the very end of the summer, I thought, "Maybe I'll go take a look at those clothespins out there." I went and stood in front of them, and I remember that when they were below the surface, they were clothespins on thè line, and when they were above the surface, they were clothespins on the line; but when I brought them in relationship to the horizon, you see, and put them in the same focus as the horizon, they became music and birds and figures and clothespins—they became everything. Somehow the tension—when they're kissing the horizon—it became a photograph. It's the smallest subject; there's nothing going on here. I mean, who the hell wants to take a picture of clothespins? It's almost embarrassing to say I made this picture of clothespins on the line. And yet, I'm very moved by it.

MACDONALD: But it's not just an intellectual metaphor. It's also an image with power of its own. Would you have attempted that with the small camera?

MEYEROWITZ: Probably not.

MACDONALD: What relationship do you see between the way you work with the 35-mm and the way you work with the 8″ x 10″?

MEYEROWITZ: Look at this photograph, for example (fig. 4). Here is a woman in a window, glazed by the orange light of the sun going down. She's wearing an orange kerchief seen against the coolness of that fluorescent light. Let's say I came across it as I got out of my car to bring my laundry in. I would have made several pictures as I stepped into the perception. As I got closer, I would have kept on changing my points of view, refining them. I would have taken four or five pictures because the small camera has those pictures to waste. You have experience in a continuous way with the small camera. That's part of what small-camera photography is about, keeping your experience sensation alive as you move.

Rather than making several images and walking away, the big camera is more about making a single picture carefully. Here, however, I worked from the intuition of a street photographer. I chose to stop right where I saw it and make the picture there instead of rushing in. I wanted

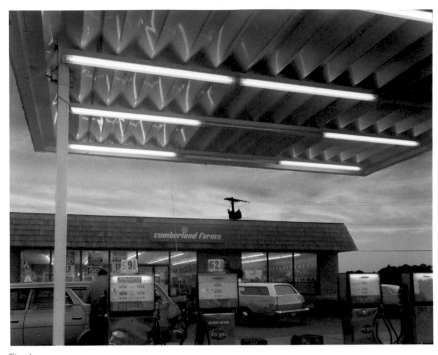

Fig. 1

Fig. 2

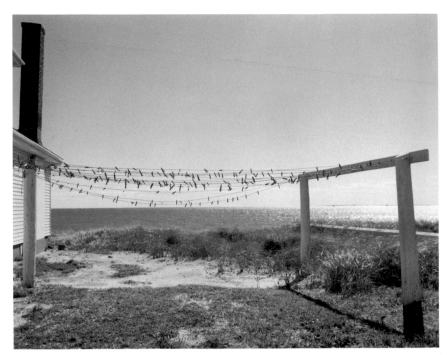

Fig. 3

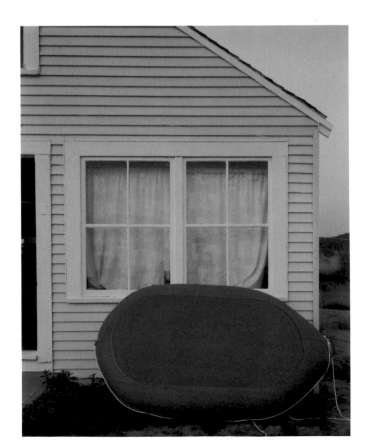

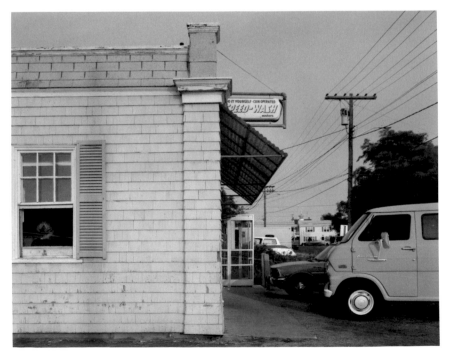

Fig. 4

the innocence of my first observation. There's a beautiful thing in the window, a gem. Any second it could disappear. So I thought, I'll sacrifice that because I'm going to get it *anyway*. I'll pull back, and I'll get one subject in the window and I'll get the entire picture too, because this plastic shade outside the building is luminous as light comes through it, just as her scarf is being illuminated. It stands against this piece of light as another receptor of light. And the reflection of the sun on this golden bus was about light. So I started to see that there was more subject there. What I *risked* in setting up the camera out here was *time* during which she might have gotten up and walked away. And I say that I'm relating to 35-mm photography here in that I made a picture of the entire thing, and I trusted that she was persuasive enough—*she's the picture.* I *stopped* because of her. But I made a picture of the entire thing: the sky, motel a block away, bus nearby, the shingles, the window.

It's the *risk* of taking a picture of the *small* thing in a big space that is exactly like the street pictures. In the street I make a picture, and I shove the subject off center, and I take a picture of the subject and the context—the subject as it stands with everything else—rather than limiting the picture just to the subject I first perceived. So I feel that's me; that's the wit of the street at work; that I'm willing to risk the distance to the subject. I'm trying to make an atonal photograph where everything is as important as everything else. It's difficult, I admit, because you have tendencies to celebrate one thing more than another. But I think it's possible to make a picture in which the photographer lays back enough so that the viewer comes into the photograph and has a chance to perceive things on his own terms, instead of only seeing what the photographer has hooked him to see. I think one of the reasons I'm using the 8″ × 10″ camera is that I felt that I could work with the large camera and make photographs in which the subject was everything in the frame.

MACDONALD: Compared with the chaos of your street photos, the pictures here seem more orderly, more formal.

MEYEROWITZ: These are slow pictures. *Energy* is what's right for the street. *Thrust* is what's right for the street. Inserting oneself, as you say, without bruising the subject in the street produces new compositions. Awkward ones, chancy ones, radical ones. Things are all slamming into the frame on the oblique. They're crashing and colliding. They suit the place very well. This place doesn't have that kind of collision. Cape Cod is a one-story place. Everything sits against the horizon. Everything is in human scale. It allows me to make formal photographs. The camera itself is formal. We're like a bride and groom. When I stand in front of a place with that camera, I'm at attention, the camera is standing at attention, the buildings are standing at attention. Everything is having its portrait taken. I'm trying to insert into that formality some vitality—some street wit.

JULY 25, ON THE BEACH

MACDONALD: You walk out in front of the whole whatever is out there and choose a piece of it. That's a difficult task because there's so *much* to choose from. It's alarming. For every good picture you make, there are a million bad pictures you didn't make. What I'm asking you is why do you stop *there*? What does *that* place have that another does not?

MEYEROWITZ: Aha! I'll tell you what it is. It's like falling in love. What happens when you're on the street, and, as you're walking along, a woman turns the corner going away from you, and for an instant you have a glimpse of the side of her face, of the gesture of her shoulder, the shape of her body, and you are *committed.* Your whole emotional response is committed. You are in love for an instant, or your senses are *rocked* for an instant. That person then disappears and is lost to you forever. What you *feel* in that instant, that glimpse of something just out of reach, is what tells you to make a photograph. It is a *feeling.* That's my physical equivalent out there. For a moment she fills that place that is always open, a place where sensation can reside for an instant. It's a flash; but that's what happens when you go to take a picture. You walk along and you're open. Hopefully, you're open. If you close yourself and then you go out looking to find *photographs,* you will only find the narrowest—it's like having blinders on—you will find exactly what you expect. It's the unexpected that you hope you'll be privileged to come across during that day. When I walk out with the camera, I'm ready for anything; that's the Zen swordsman's motto: expect nothing, be prepared for everything. If your feelings have gotten to you, at that moment, then maybe what you're seeing will get into the photograph. You will have been *clear.* I don't know if I can say more. It's exhausting to try and pin down intuition.

JULY 22, ON THE DECK

MACDONALD: Considering what you're doing now, can you talk about what photographic traditions you see yourself coming from? Can you think about the people to whom you owe debts?

MEYEROWITZ: Absolutely. At the beginning my guide and constant resource was Robert Frank, to whom I still owe a great deal. My initial desire to make photographs came from seeing him work. One afternoon while I was an art director, I was sent down to watch this man Robert Frank photograph some little girls in an apartment. I didn't know who he was; he was just a photographer. I watched him do the most wonderful physical things: passing the camera in front of his face, hardly looking through, talking to the girls, dancing, so easy, so fluid. I was spirited away by his intensity and his movement. I couldn't imagine that he could make photographs while he moved—it just enchanted me. It seemed impossible; I thought you had to hold still, take a breath, tell everybody to stop, that the camera could stop everything while moving fascinated me.

I went back to the office and I told them that I was leaving on Friday. I had something else to do. I went out and bought a camera and started photographing. Months later, a man named Harry Gordon gave me a book of photographs. It was called *The Americans* by Robert Frank and it did it all over again—just brought me wide awake, instantly. It was all there. I learned so much by looking at those photographs—his commitment and the clear note of his passion.

At that time I had no idea that photography as a serious form really existed. I was naive. But I went out to take pictures. I went to Fifth Avenue because it was *filled* with activity and that's what I wanted to photograph. I saw other photographers there. After a year of working I bumped into the same people enough times to realize there were others fishing in the same stream.

MACDONALD: Who did you see there?

MEYEROWITZ: Garry Winogrand, Lee Friedlander, Diane Arbus. But I kept running into Garry Winogrand. The first day out I saw this curly-headed guy on the streets and he saw me. The next time I bumped into him on the train going to the Bronx. I was going to visit my mother and he was going to visit the zoo. We lived in the same neighborhood, and we used to meet on Fifth Avenue and walk, often going through the zoo on the way home. From Garry Winogrand I learned about a sense of life—his presence, his terrific vitality, a bull with angel's feet, intense and humorous and generous. Garry was out there, rain or snow or summer, pounding the streets every day with a kind of inexhaustible passion—a need to be soaking in the street. That was good. I saw that you could do that; there was a life there. Also his radical view of things—the way he sights them across their oblique face—those chorus lines of his. He just knocks the edge off things and reveals a new facet.

In the beginning I worked with Tony Ray Jones and Richard Horowitz. Tony's dead and Richard's a commercial photographer now. Somehow we found each other. We used to go to the parades and work the beginnings and ends, but not the middle. We didn't take pictures of the parade itself. We photographed when they were coming together and when they broke down at the end. There we had license to play. You could go right up to people. You could break the social distance. You didn't have to keep the distance of a news photograph. You could get into more intimate situations.

I met Cartier-Bresson for the first time in 1963, when I first started, at the St. Patrick's Day parade. I saw a man jumping around, bobbing and weaving, twisting and turning, dancing; he was just terrific. I said to Tony Ray Jones, "I think that's Cartier-Bresson." We had already seen his book, *The Decisive Moment.* That was one of the great introductions to photography. We figured this must be the man who made those pictures. I was elected to go over and talk to

him. I had a beard and long hair and I wore a poncho. I went over and said, "Excuse me, are you Henri Cartier-Bresson?" He said, "No! No! No! I'm not Cartier-Bresson—are you the police?" I said, "No, no, I'm sorry; I'm just trying to take pictures here. *We* [and there's Horowitz and Ray Jones standing there suddenly very interested in the details of brownstone architecture]—we thought that maybe you were Bresson because you were doing things like nobody we ever saw." He grabbed my poncho, and he said, "I'm Cartier-Bresson. You meet me here afterwards and I take you for coffee." I ran to a 'phone booth and called Vivian, and I said, "I JUST MET CARTIER-BRESSON!" I was shaking; I was *shaking!* I couldn't believe that we would have the luck to meet the master in this situation. *We saw him.* We stood together and watched a drunk lurch out of the crowd and try and take Bresson's camera. He *threw* his camera at the man's face, but his camera was tied to his wrist. The man *fell* backwards into the crowd without being hit. Bresson hauled the camera in like a yo-yo, *whirled* around—his trenchcoat did a ballet spin around his body—and off he went like Groucho Marx into the next section. By the time the drunk stood up, Bresson was gone. He was invisible. We stood there, and all we saw was that *the camera was tied to his wrist.* We tied our cameras to our wrists and practiced this yo-yo gesture so you could bring it back without hitting yourself in the face. You could knock yourself out, break your lens or something. Sure enough, we met a couple of hours later, and he took us for coffee. In the middle of New York, he did the classic thing that you always hear about. We were walking on 86th Street and Third Avenue, and while we were talking all of a sudden there's no Bresson! There's this man, running up a flight of stairs, taking a picture, and running down, coming back without missing a beat. Then he took us to a cafe; we had espresso and talked, and it was *nice.* Years later I met him again, and he *remembered* that afternoon. I mean, I couldn't believe that a man with a million afternoons, meeting photographers all over the world, would *remember* the three of us and that special afternoon.

JULY 26, DURING LUNCH

MACDONALD: I've been pressing you toward what it is you're responding to in making these photographs. In your black-and-white work I can define verbally what I think you are doing. I'm beginning to understand that in this work you're responding to the act of vision itself—just the pleasure of seeing. The other night you said that deprivation of light is something human beings can suffer from. That deprivation of the visual act, *per se,* is painful. I suppose one of the horrors of being in prison is that you see the same walls over and over again. It's an enormous pleasure to go outside and look at the patterns of trees. As I sit here, I've been playing visual games with the verticals on that balustrade and the squares of these windows. I was catching people walking

along the beach, inside of these little spaces. We do that without even thinking. There simply is pleasure in the act of vision itself.

Other contemporary photographers, when using an 8″ × 10″ camera, it seems to me, have been more academic. They have decided in advance to a greater degree what it was that they would respond to. They would look for color opposites, tone contrasts, specific kinds of subject matter, motion. I don't find much of this in your Provincetown photographs. There is occasionally some sense in which you're responding to pattern, and to luscious combinations of color. One of the things you did in your earlier work was to play games with scale—there's very little of that here.

MEYEROWITZ: Not true. Scale is a very important part of these.

MACDONALD: All right. Talk about that.

MEYEROWITZ: Well, it's only one aspect. I disagree with you to a certain extent because I think that it's a mixture of all of those components that I'm photographing. It isn't one to the exclusion of others. I'm interested in scale because I'm in a place where scale exists—tiny people on vast flats against the sea and the sky, buildings seen from far away. I'm photographing details of buildings because the buildings here are wonderful; their parts are beautifully stated. The color isn't lush; it's actually spare. Sunlight on things, bleached-out colors, weather-worn colors are part of the visual condition that exists daily.

I don't really want to talk about one aspect of these pictures more than the rest. The fact is, I'm trying to photograph the wholeness of my experience. I'm trying to pass that experience back into the world. What you said a minute ago—about sitting here with your eyes wandering, matching up the lattice work on the balustrade with the tiny figures passing through the spaces—you were making observations pure and simple. If you made a picture of that, you would refer that to the world. The world would look at the picture and say, "Yes, I could see that too; I'll look for that." All I'm trying to do is pass experience. I see things—this is my life—I look; I make visual images. It's the best in me—the only thing I can do. It's what I've done since I was a kid, I feel things. When I was a kid, I used to walk and drag my hands along. the walls so I could feel the roughness of the brick, the smoothness of the mortar, the shine of the paint. I remember the texture of my mother's face. I used to wear out her furniture from rubbing and feeling. I always carried something in my hand. I love sensation! But, within the limited range of sensations that I am responsive to, certain optical things excite me. This is the shape my life has. A painter paints his visual experiences; a musician encodes his aural experiences; each finds a way of transmitting them. We are emission centers. We receive sensations and we put them out. That's what artists do. I can receive on any given day, more or less

clearly, depending upon how in touch with the signals I am. If I'm in a good place, where there's a lot of visual activity, I become supersensitive. I receive many signals, and I pick and choose among them. As they get deeper into my center, to the core of this receiver, I feel more strongly about them, and I say *this* is the one that I am moved by. I can't say that it's the scale that did it. The scale yesterday may make me make a picture. But today this fence post has nothing to do with the scale yesterday.

Very simply, I'm sensitive to colored space and the envelope of light enfolding things. I go around taking them in, passing them along. I try not to have a hierarchy of values about these photographs. I'm just trying to find things that are interesting, and for all kinds of reasons. I don't know how that relates to the world of ideas. I'm not a thinker. I don't think grand and universal thoughts. I feel sometimes when I'm really slipping along with no friction that I can see grand and wonderful sights. Hopefully, at that moment, I will become transparent.

The thing that friends have said about these pictures, which has delighted me more than anything else is, "I feel like I've *been* to this place." What are they saying? They are telling me the most wonderful thing. They're not saying to me, "You're a good photographer." They're saying, "I've had an experience—I've just *been* there—I *stood* in front of that building—I've felt the weight of the shadow—I've stood on your porch and looked out."

I put myself here in Provincetown, a place where I wouldn't have the normal sensations that I have year round in big cities. I'm perfectly happy here just going out and standing in the stream of this place and feeling. I feel Aeolian. I'm a harp; the wind is blowing through me; it's making music, on its own. I think that that's the most that anybody could ask for in the capture of their experience. It should just waft through you—a fragrance—effortless. You should be in tune in such a way that there's no resistance. Whether you're making images, poetry, painting, music, or love, you should be totally enraptured by that, by the experience itself. That's what it is about—the location of subject, it's about passage of the experience itself, in its wholeness, through you, back into the world, selected out by your native instincts. That's what artists do. They separate their experience from the totality, from raw experience, and it's the quality of their selections that makes *them* visible to the world.

What is the art experience about? Really, I'm not interested in making "Art" at all. I never, ever, think about it. To say the word "Art," it's almost like a curse on art. I do know that I want to try to get closer to myself. The older I get, the more indications I have about what it is to get closer to yourself. You try less hard. I just want to be.

MACDONALD: I've been pushing you in the same direction for a couple of days.

MEYEROWITZ: Making any statement of your feelings is risky. It's just like making pictures.

PLATE 1 HARTWIG HOUSE, TRURO, 1976 (cat. 1)

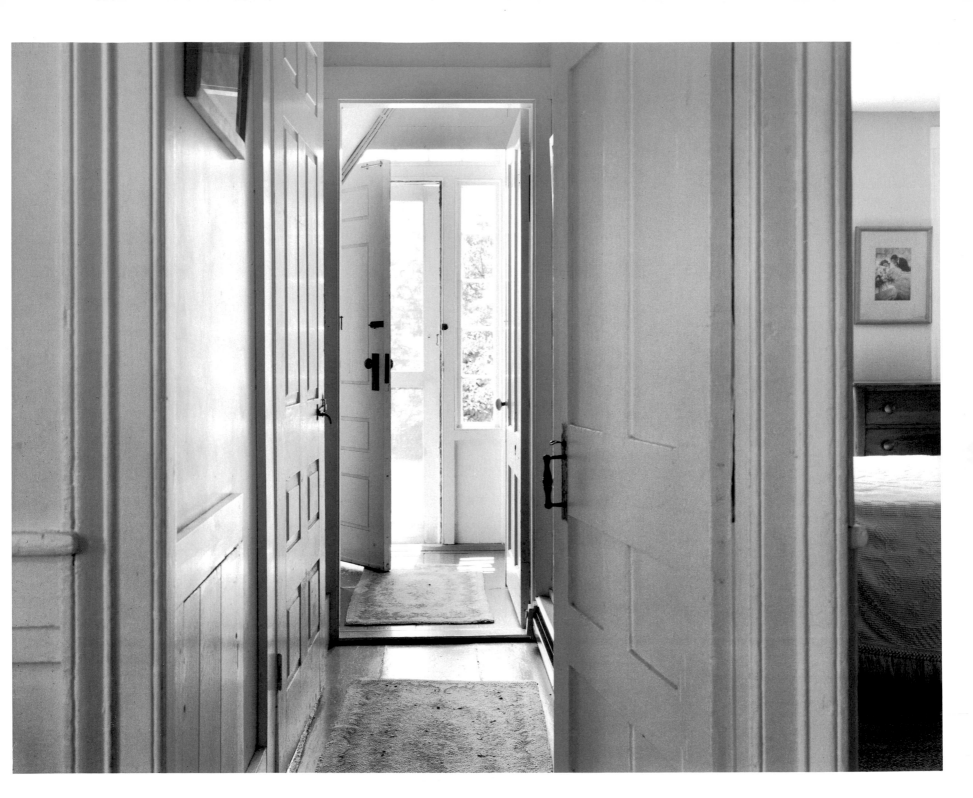

PLATE 2 COLD STORAGE BEACH, TRURO, 1976 (cat.3)

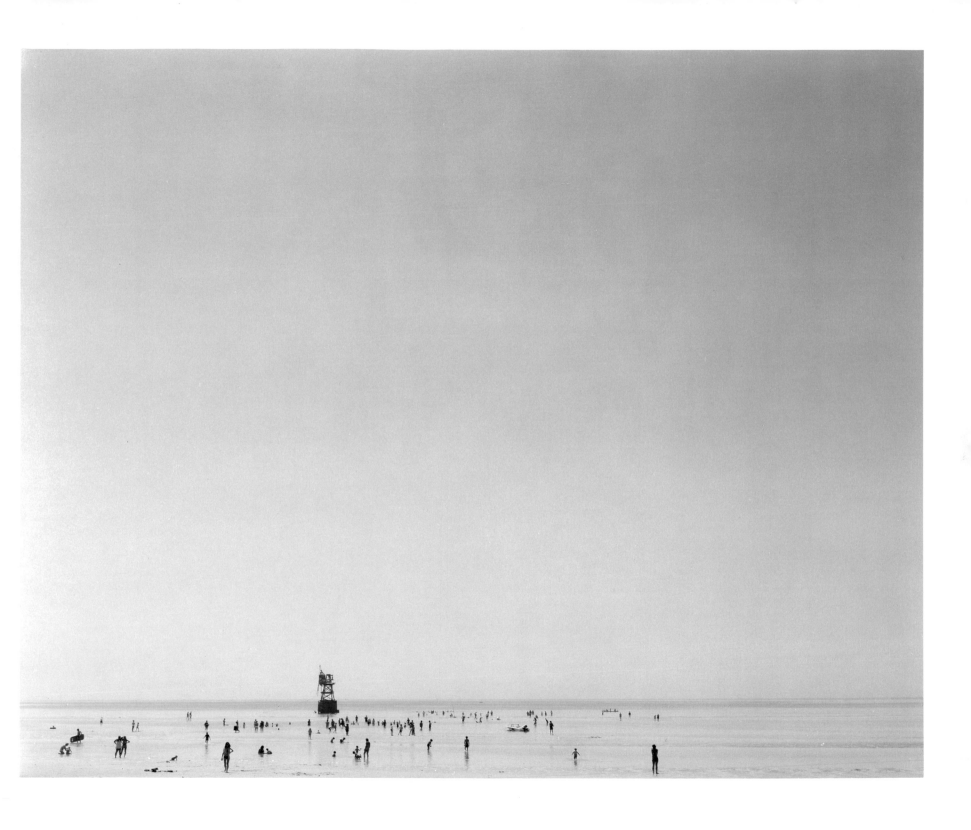

PLATE 3 PORCH, PROVINCETOWN, 1977 (cat. 87)

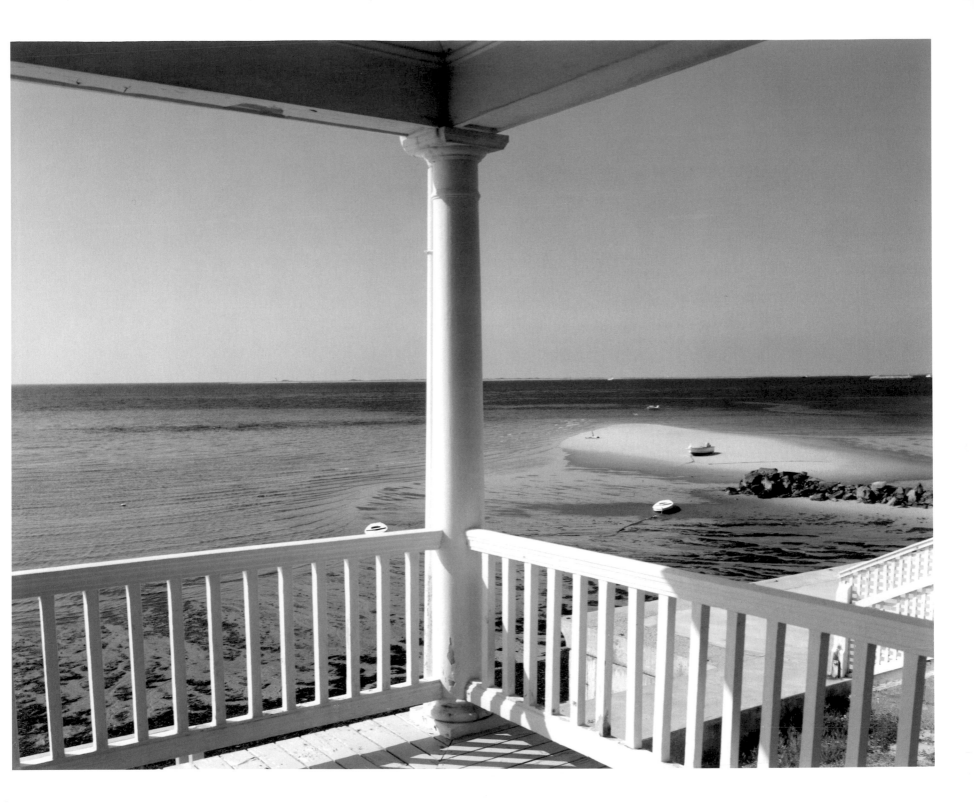

PLATE 4 PORCH, PROVINCETOWN, 1977 (cat. 56)

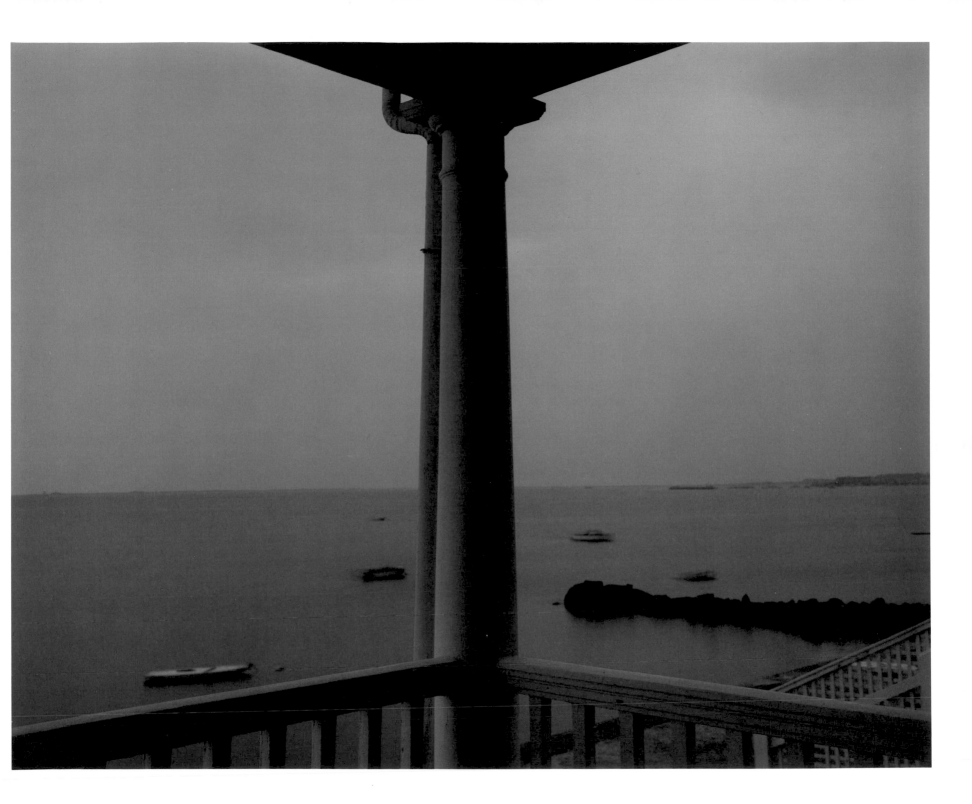

PLATE 5 PORCH, PROVINCETOWN, 1977 (cat. 39)

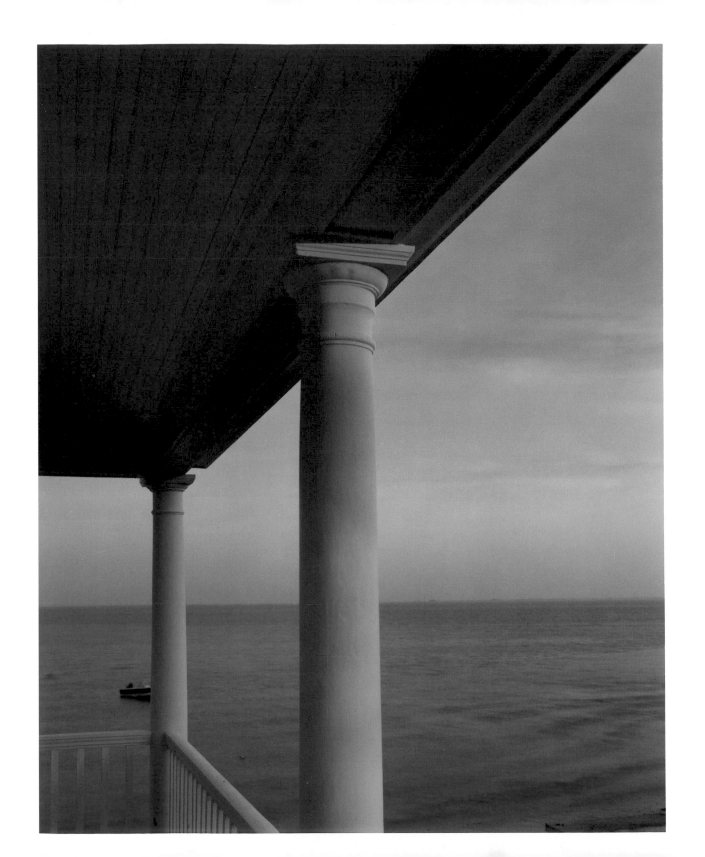

PLATE 6 PORCH, PROVINCETOWN, 1977 (cat. 48)

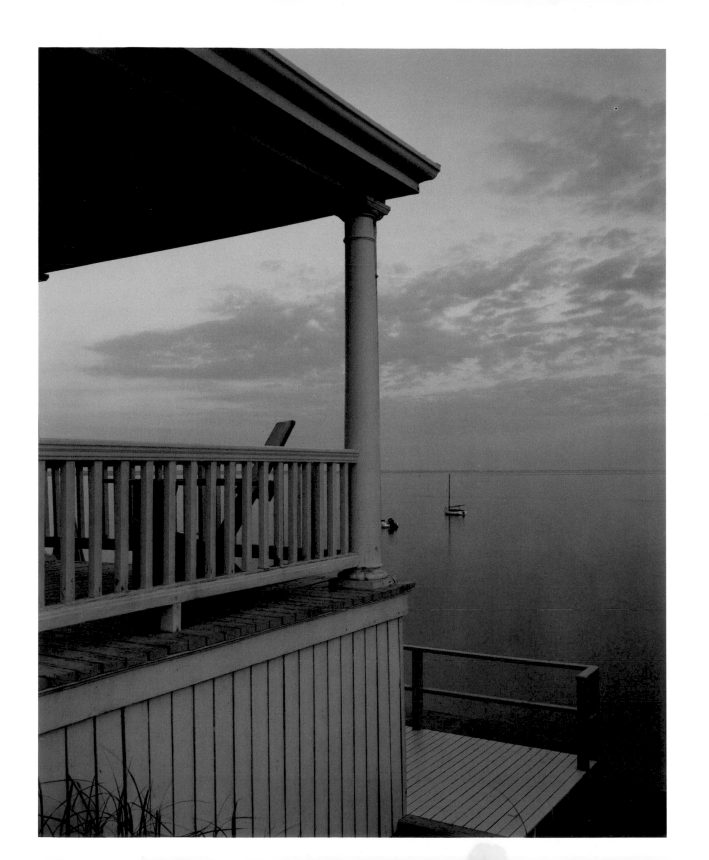

PLATE 7 PORCH, PROVINCETOWN, 1977 (cat. 57)

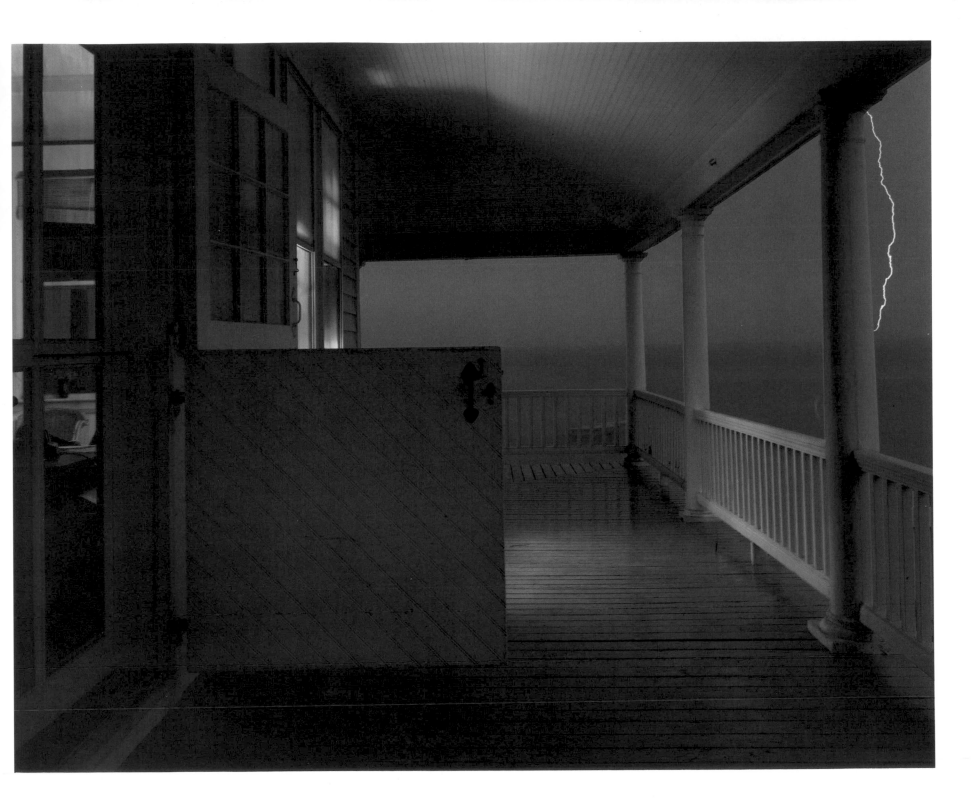

PLATE 8 BALLSTON BEACH, TRURO, 1976 (cat. 10)

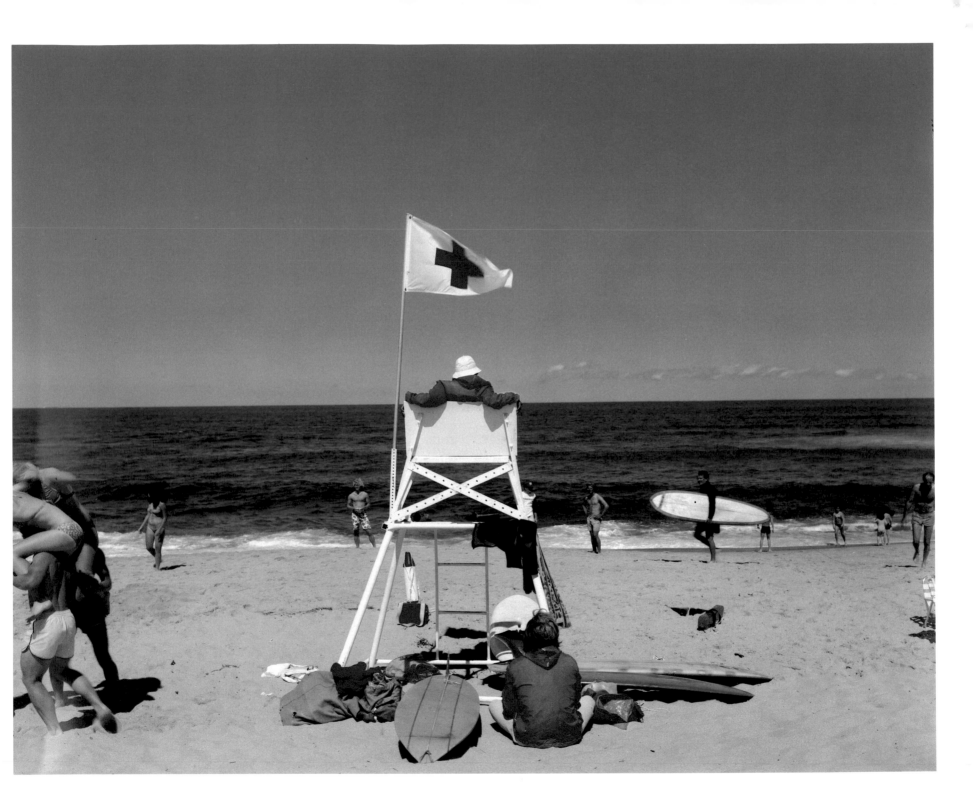

PLATE 9 PROVINCETOWN, 1977 (cat.76)

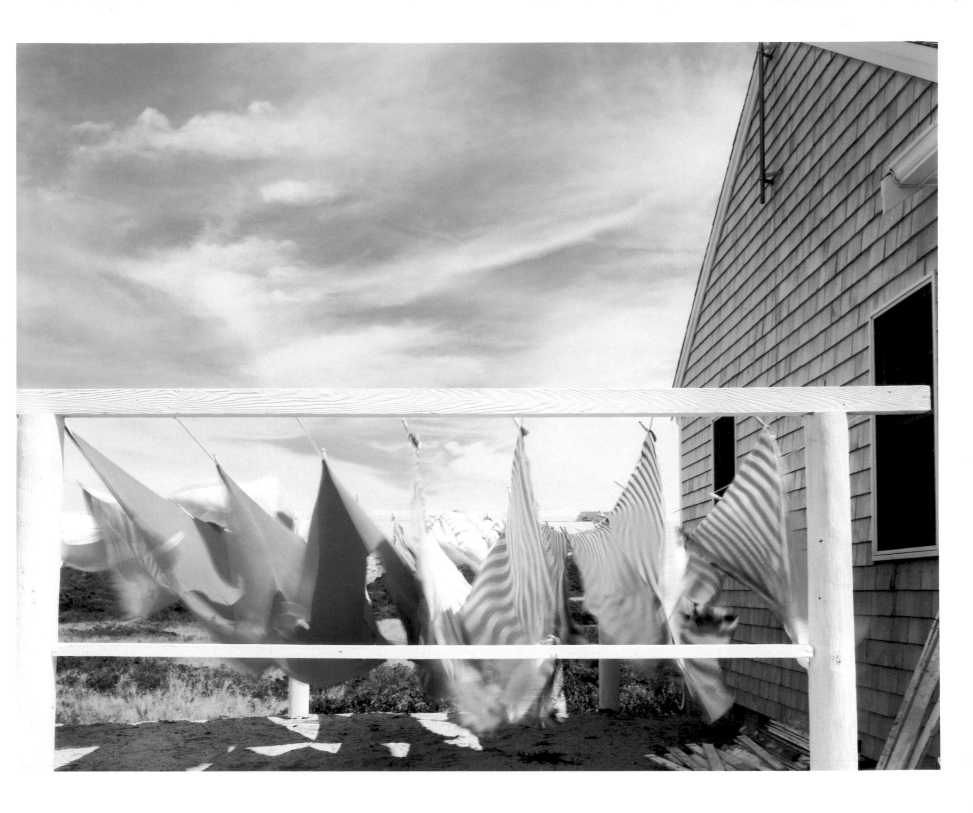

PLATE 10 COCKTAIL PARTY, WELLFLEET, 1977 (cat. 44)

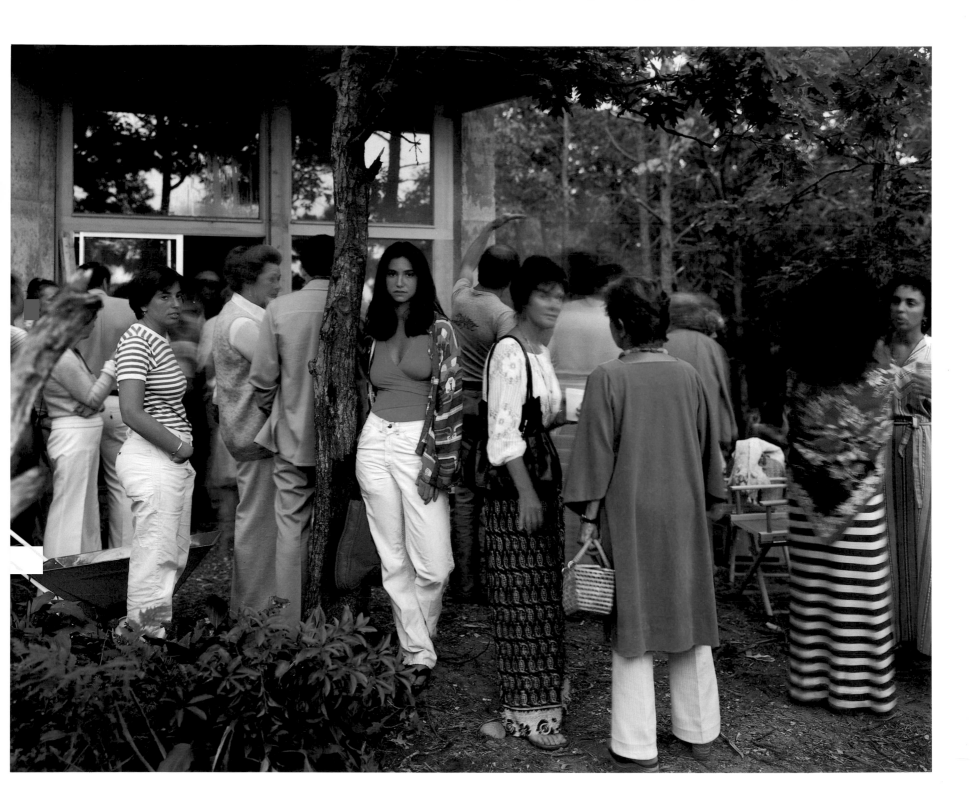

PLATE II PROVINCETOWN, 1977 (cat. 72)

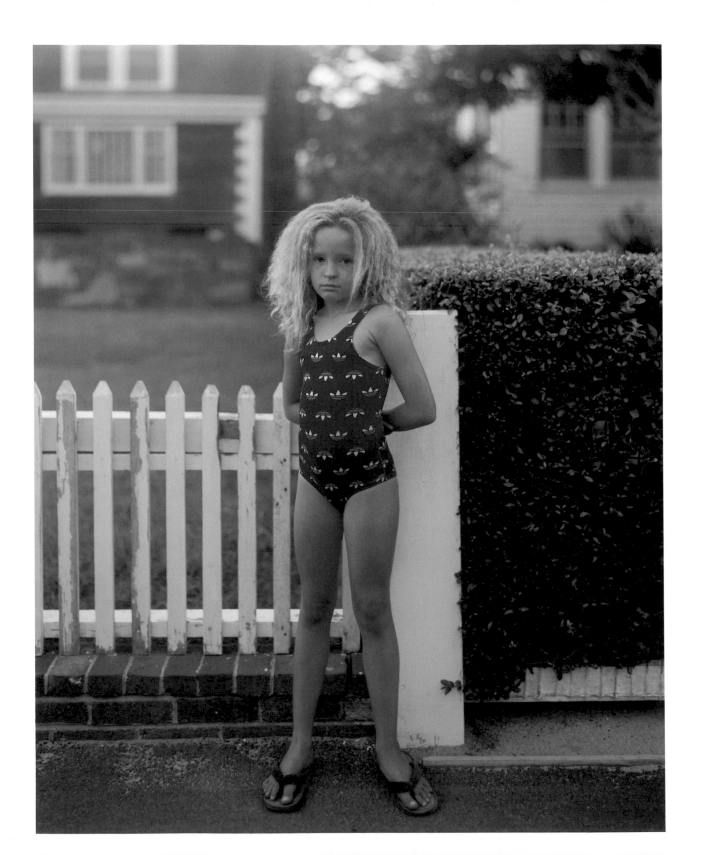

PLATE 12 BALLSTON BEACH, TRURO, 1976 (cat. 22)

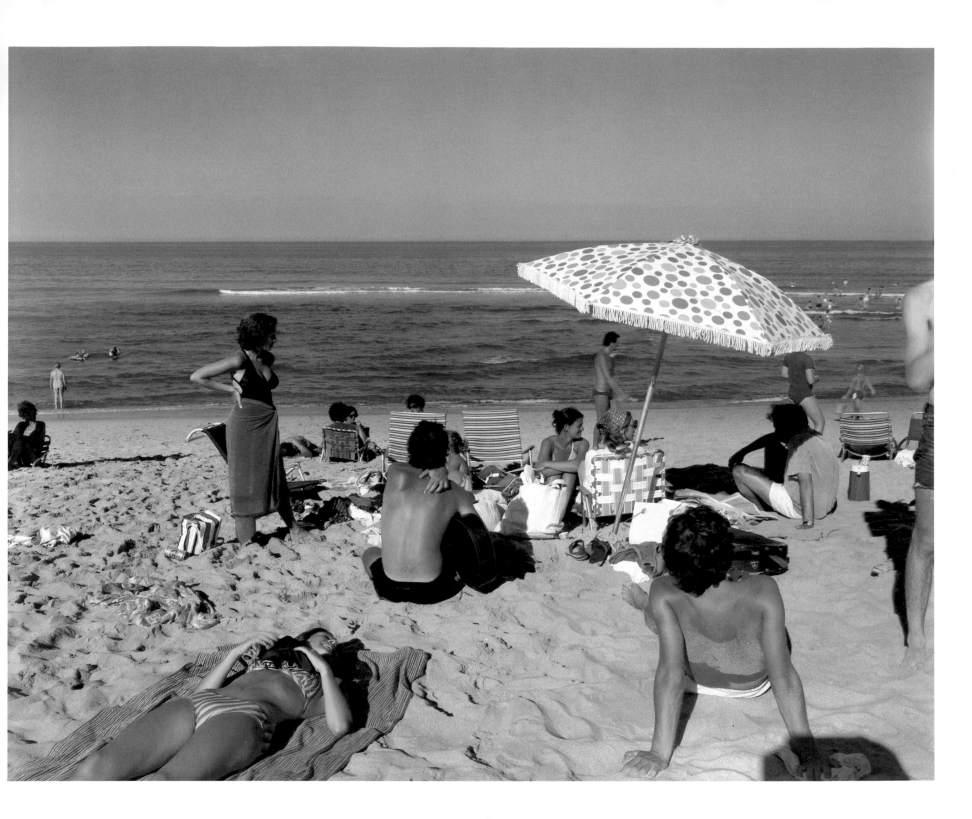

PLATE 13 PROVINCETOWN, 1977 (cat. 50)

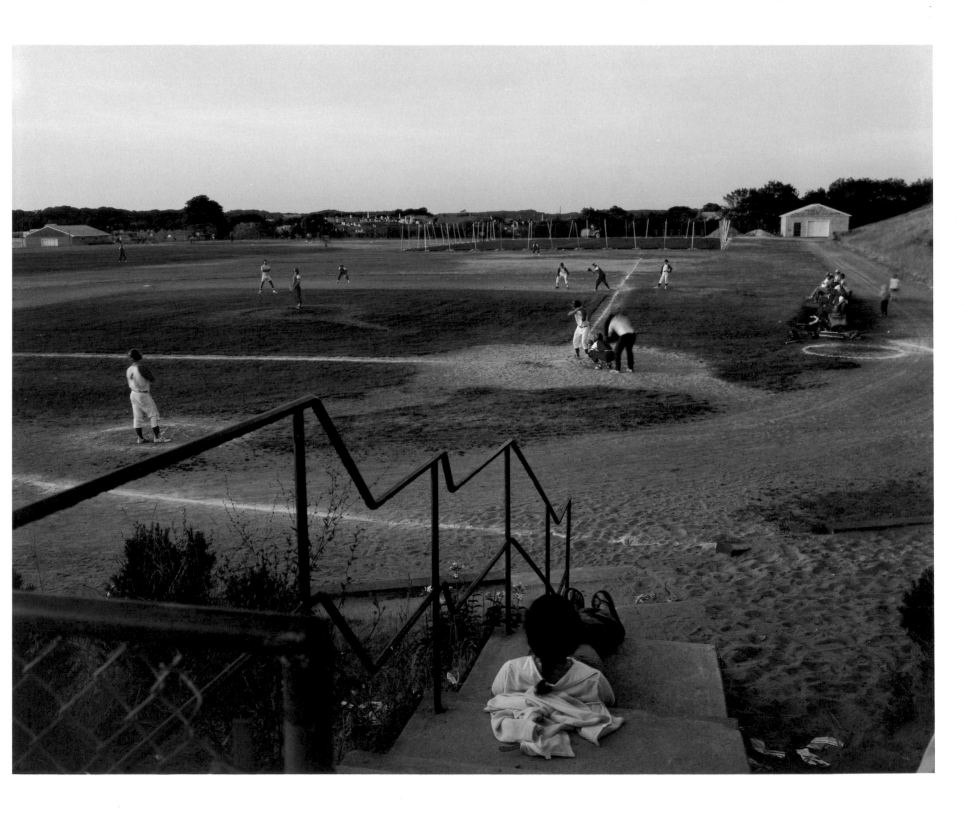

PLATE 14 PROVINCETOWN, 1976 (cat. 18)

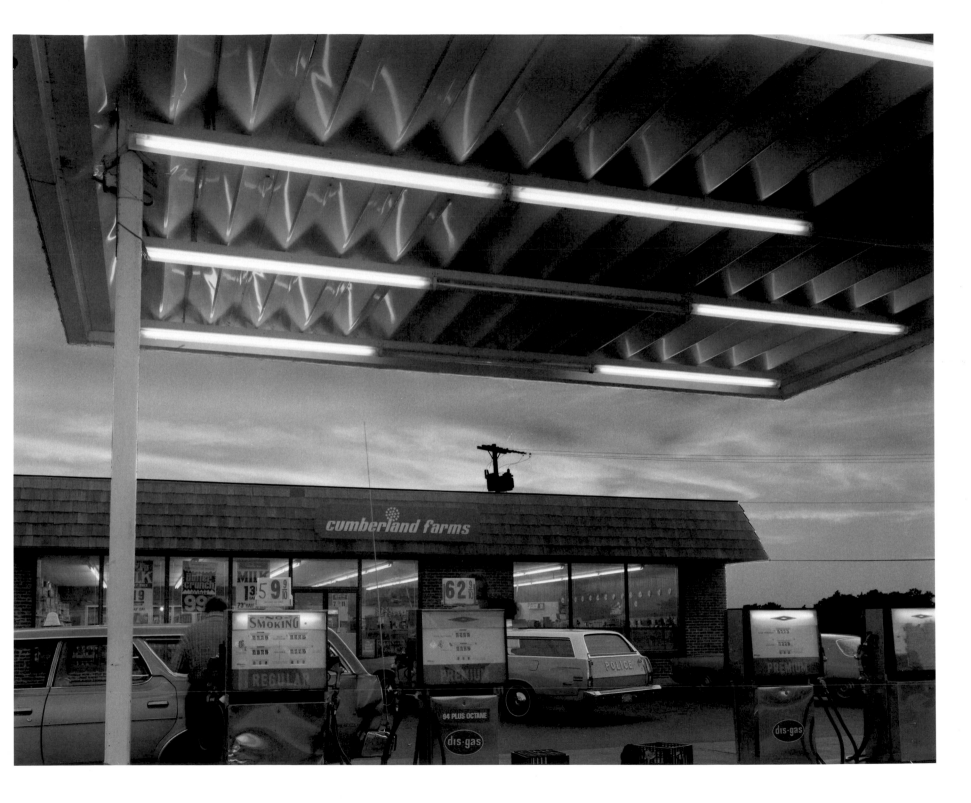

PLATE 15 PROVINCETOWN, 1976 (cat. 15)

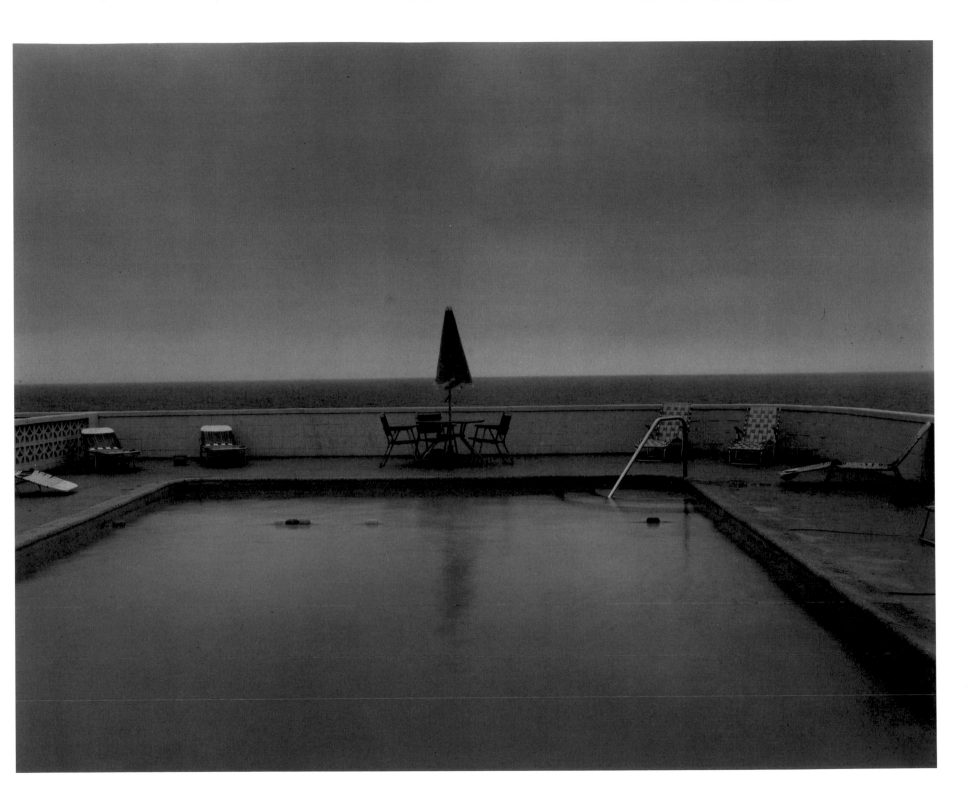

PLATE 16 PROVINCETOWN, 1977 (cat. 54)

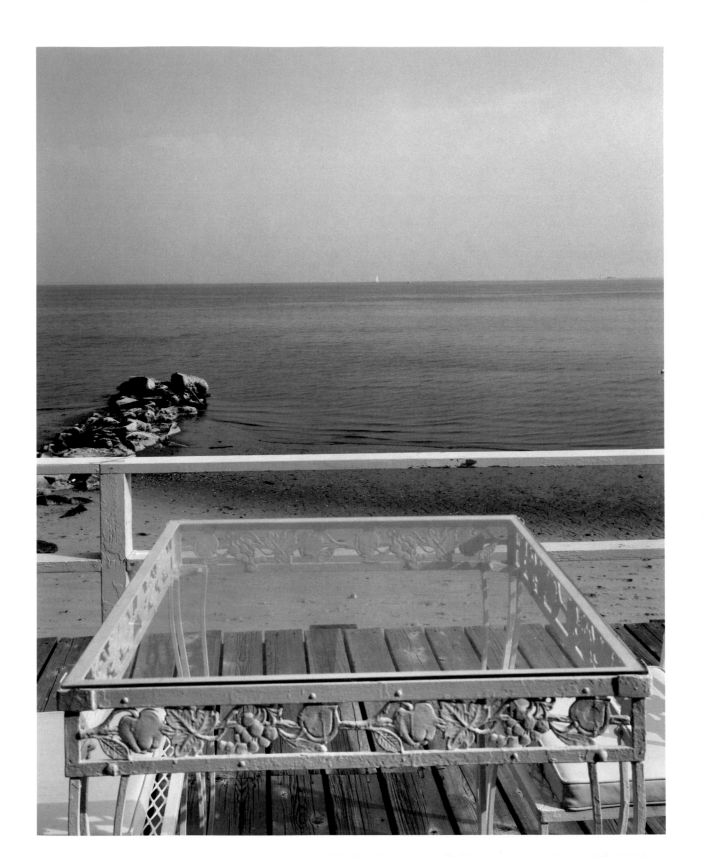

PLATE 17 "FLYING" STAIRWAY, PROVINCETOWN, 1976 (cat. 21)

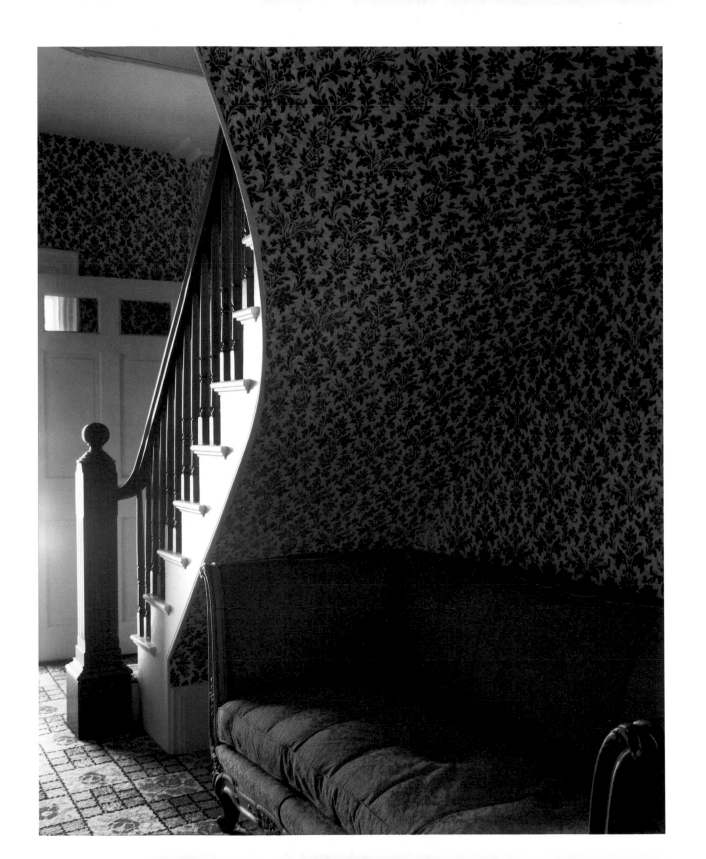

PLATE 18 PROVINCETOWN, 1976 (cat. 30)

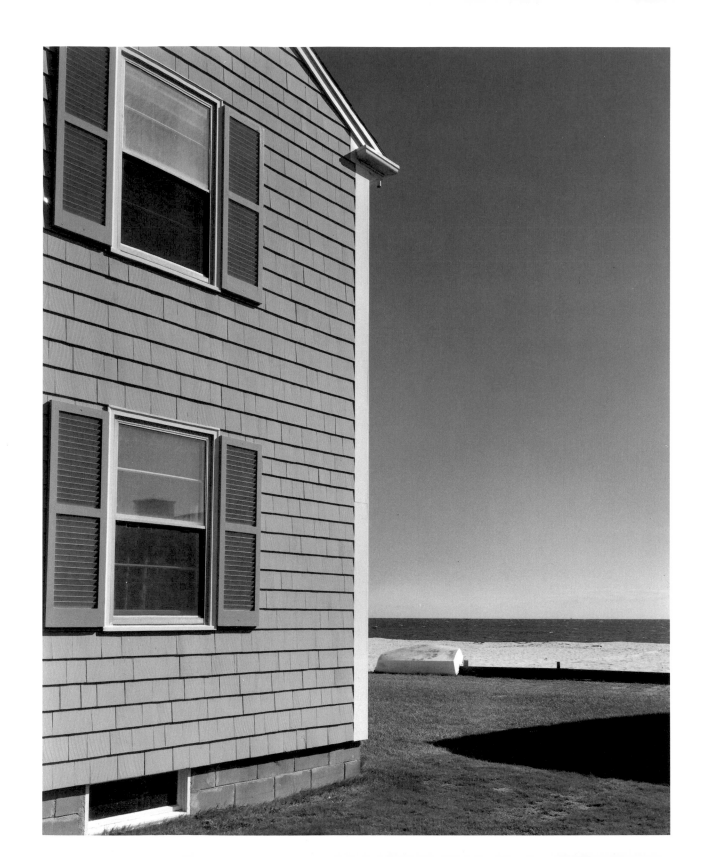

PLATE 19 PROVINCETOWN, 1977 (cat.74)

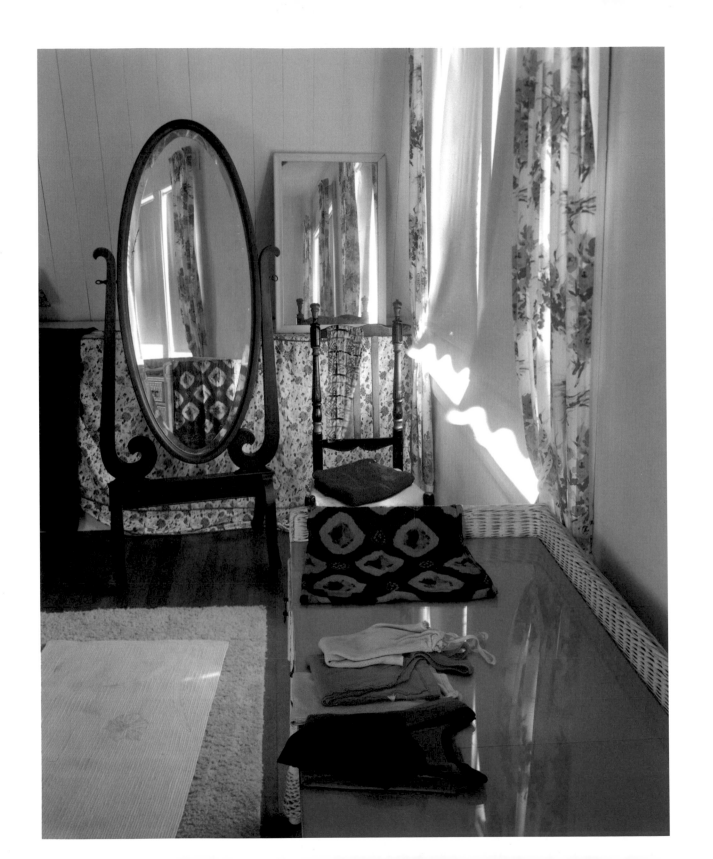

PLATE 20 TRURO, 1976 (cat. 8)

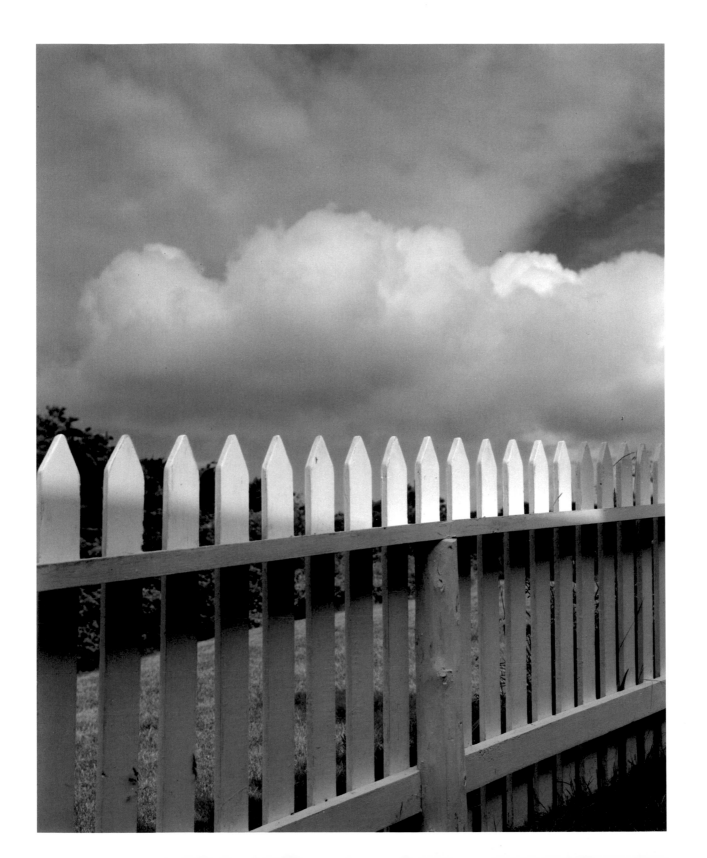

PLATE 21 BAY/SKY, PROVINCETOWN, 1977 (cat. 66)

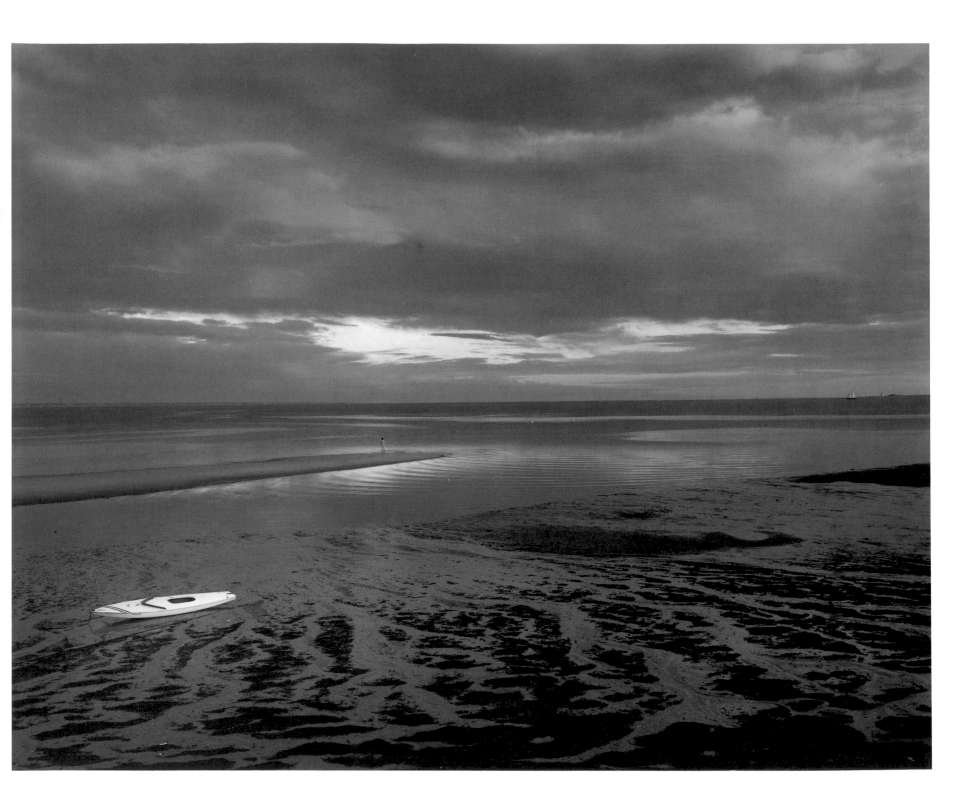

PLATE 22 BAY/SKY, PROVINCETOWN, 1977 (cat.84)

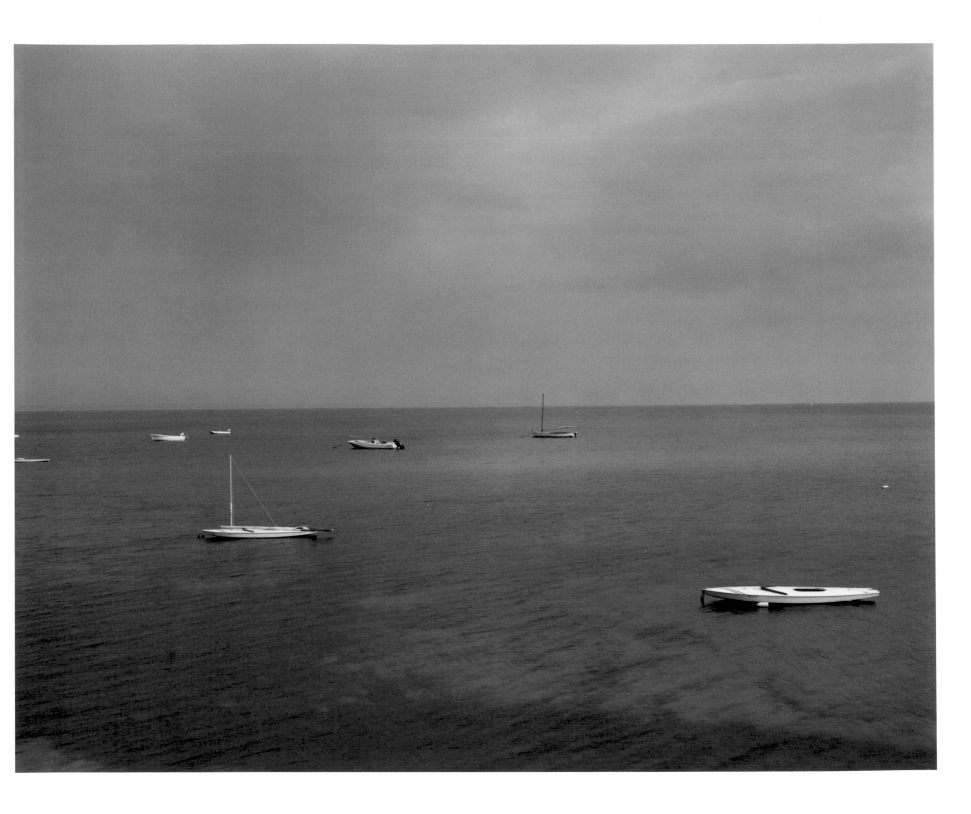

PLATE 23 BAY/SKY, PROVINCETOWN, 1977 (cat.43)

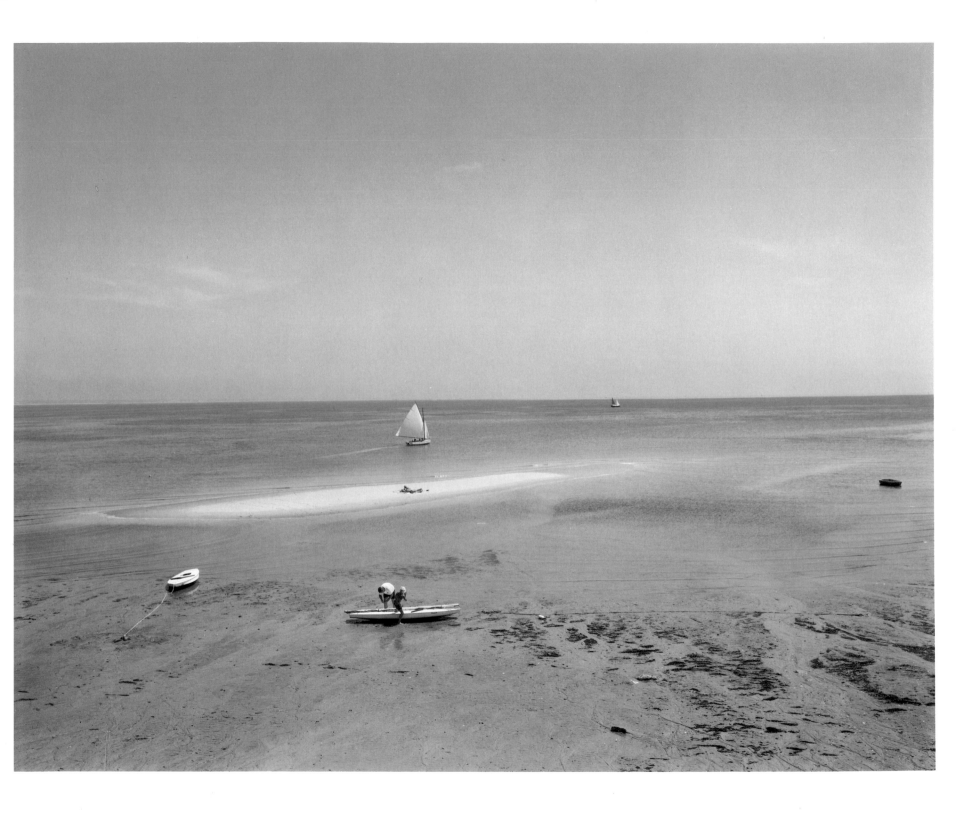

PLATE 24 BAY/SKY, PROVINCETOWN, 1977 (cat. 89)

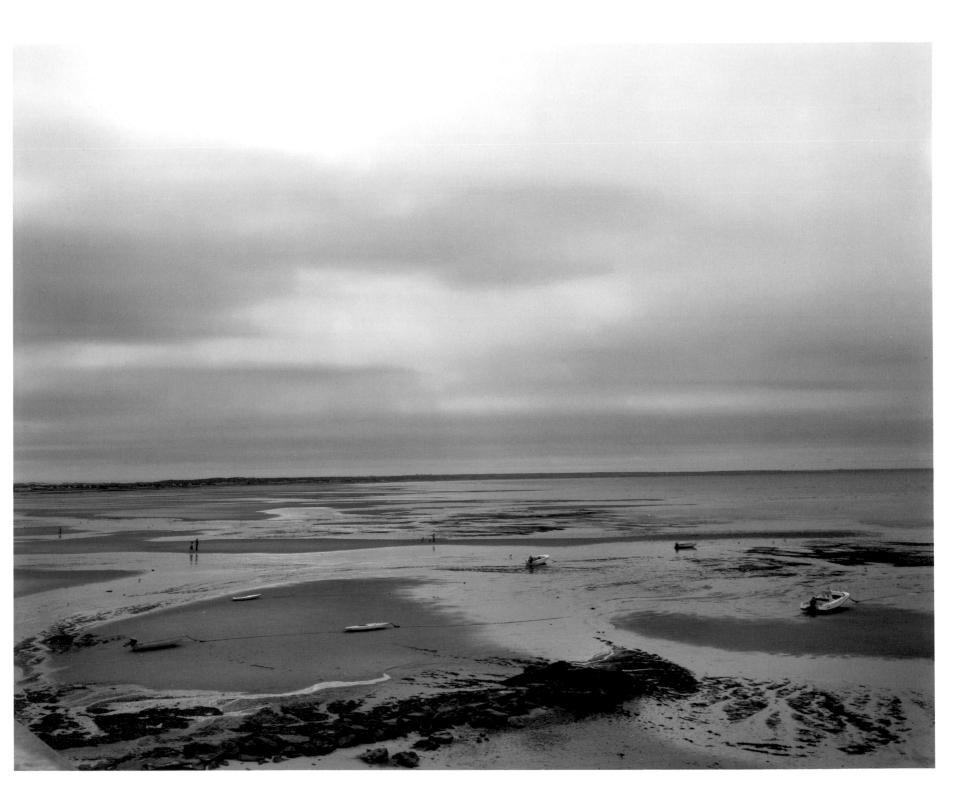

PLATE 25 BAY/SKY, PROVINCETOWN, 1976 (cat. 33)

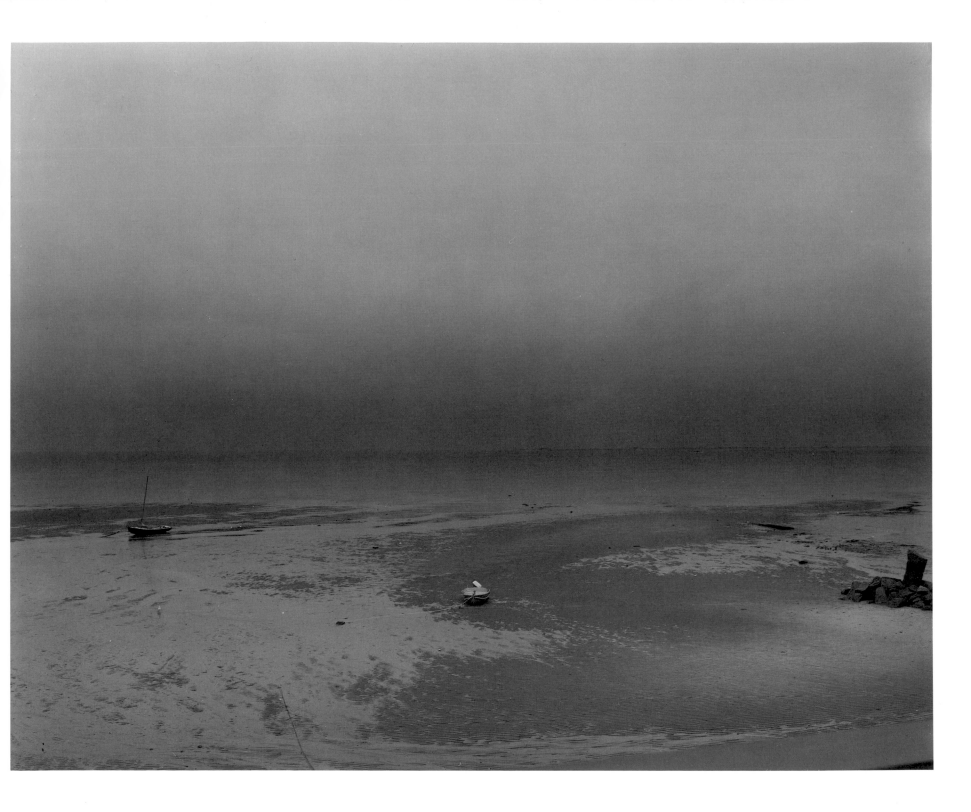

PLATE 26 TRURO, 1976 (cat.7)

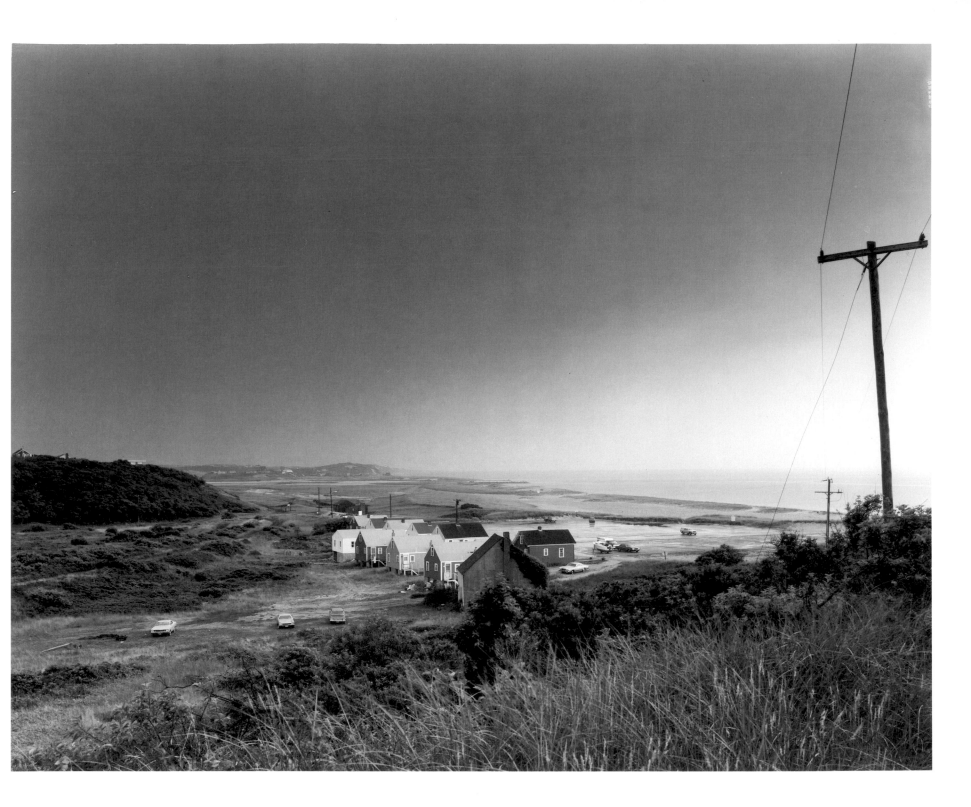

PLATE 27 RED INTERIOR, PROVINCETOWN, 1977 (cat.63)

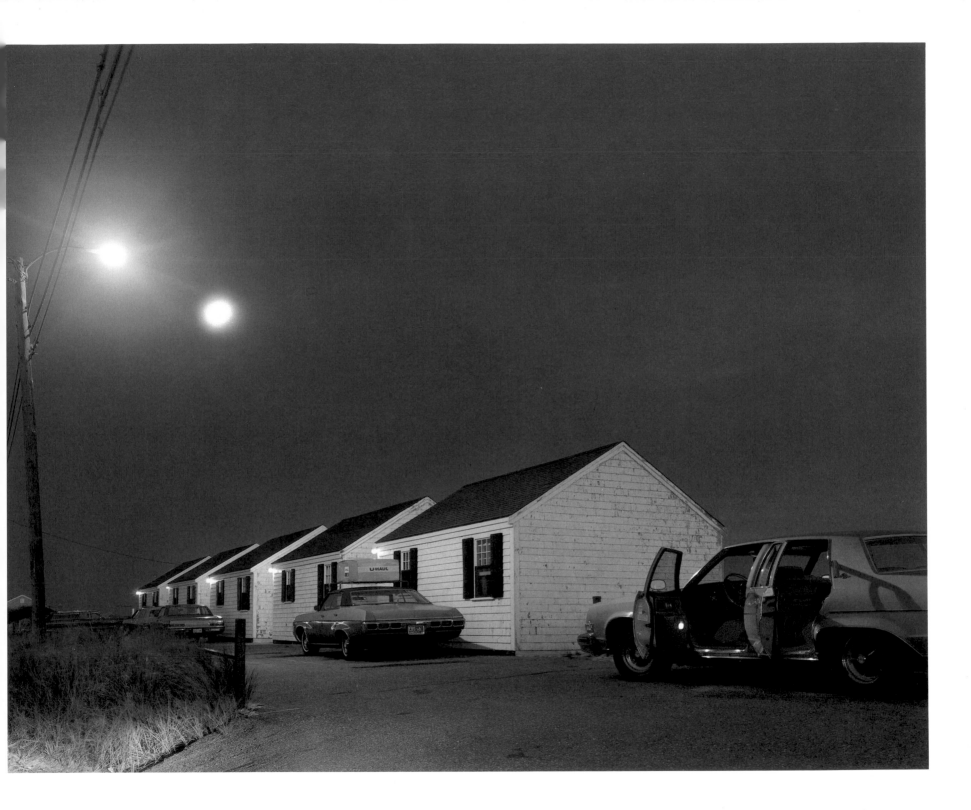

PLATE 28 PROVINCETOWN, 1977 (cat. 70)

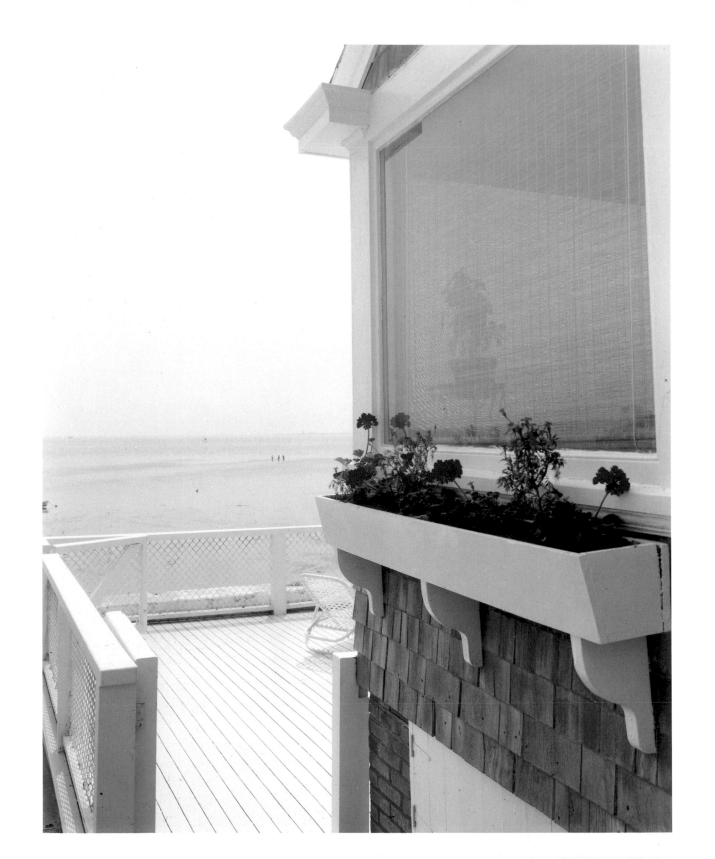

PLATE 29 TRURO, 1976 (cat.4)

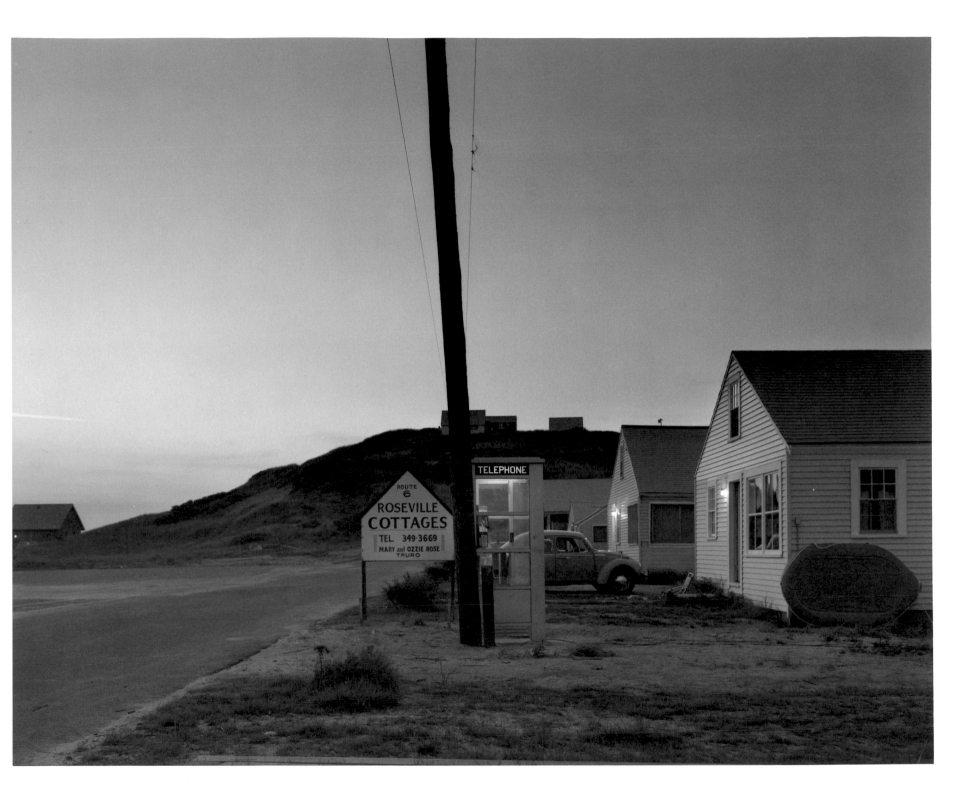

PLATE 30 PROVINCETOWN, 1976 (cat.19)

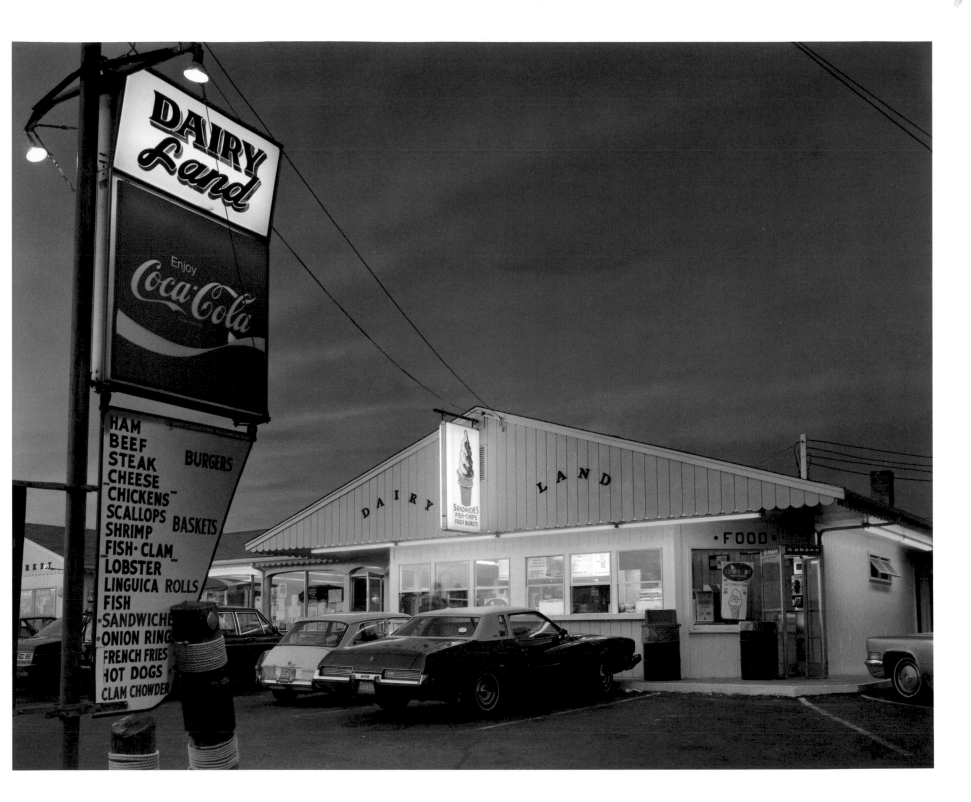

PLATE 31 TROMPE-L'OEIL INTERIOR, PROVINCETOWN, 1977 (cat. 91)

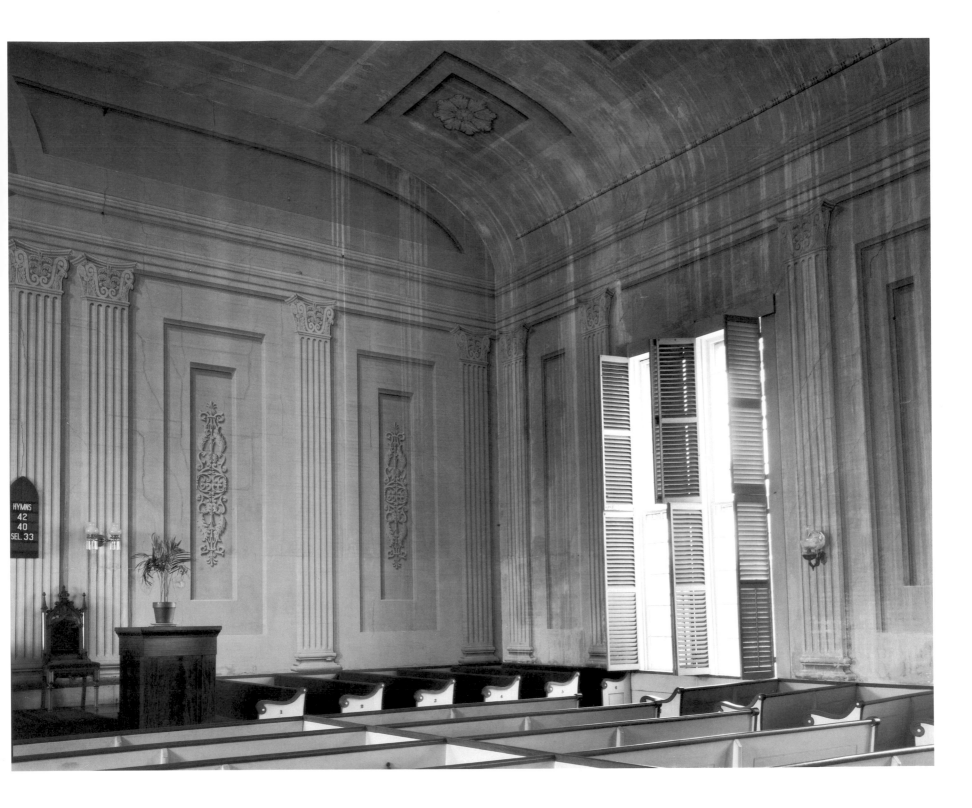

PLATE 32 WILSON COTTAGE, WELLFLEET, 1976 (cat.11)

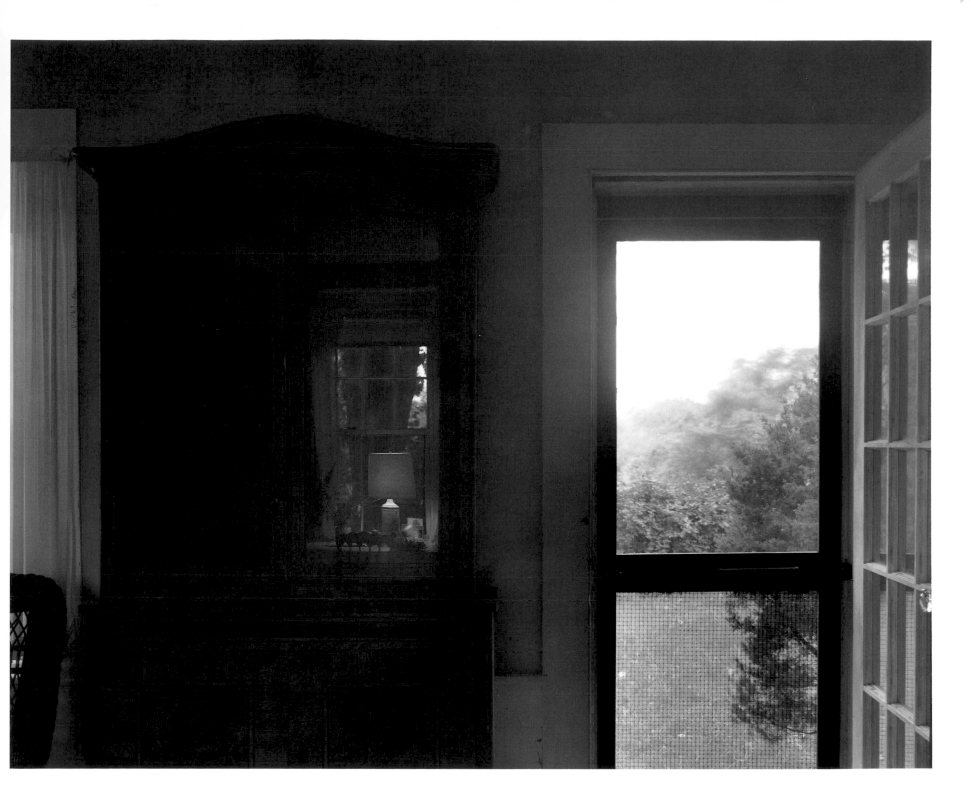

PLATE 33 PROVINCETOWN, 1977 (cat. 93)

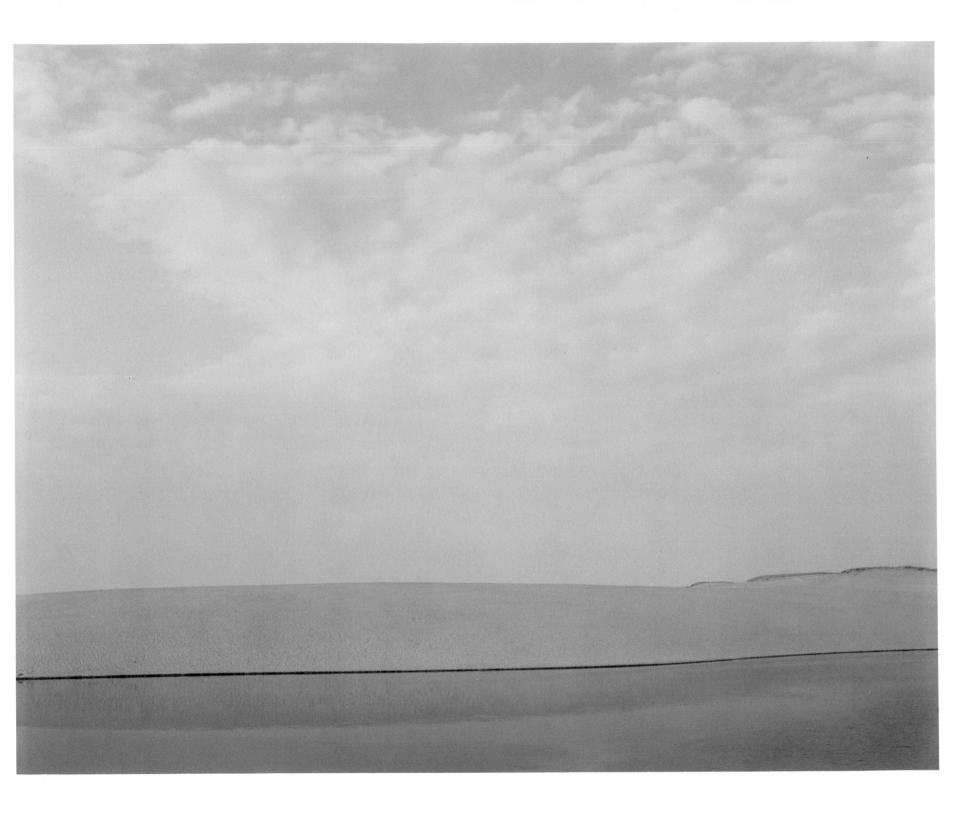

PLATE 34 VIVIAN, 1976 (cat.34)

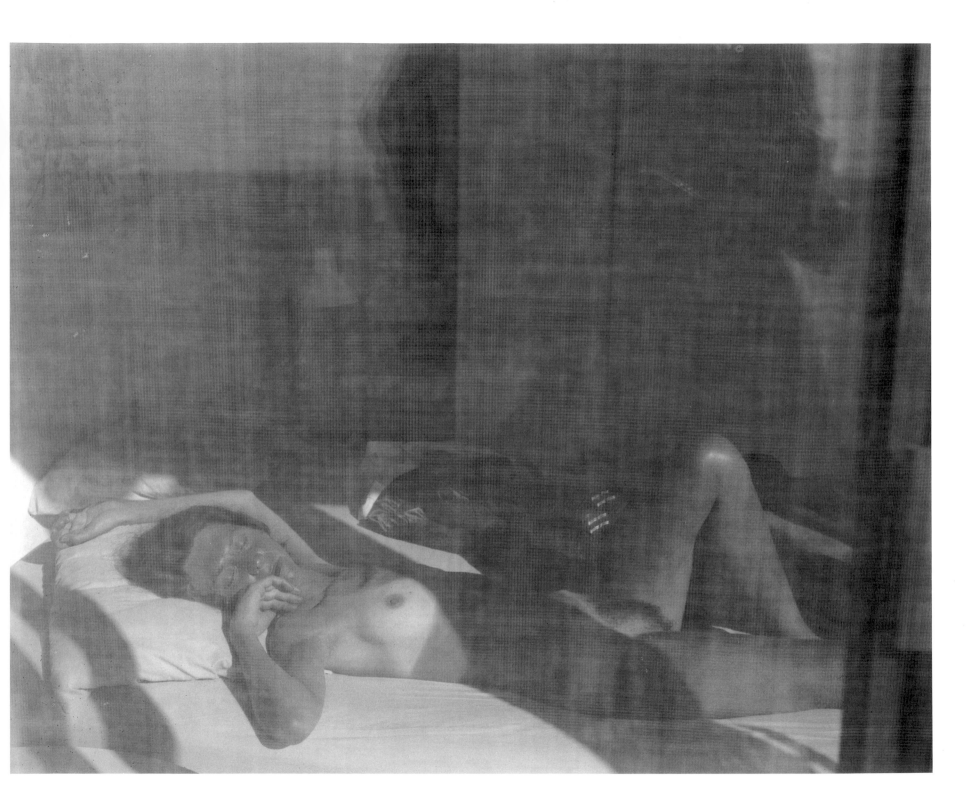

PLATE 35 PROVINCETOWN, 1977 (cat.79)

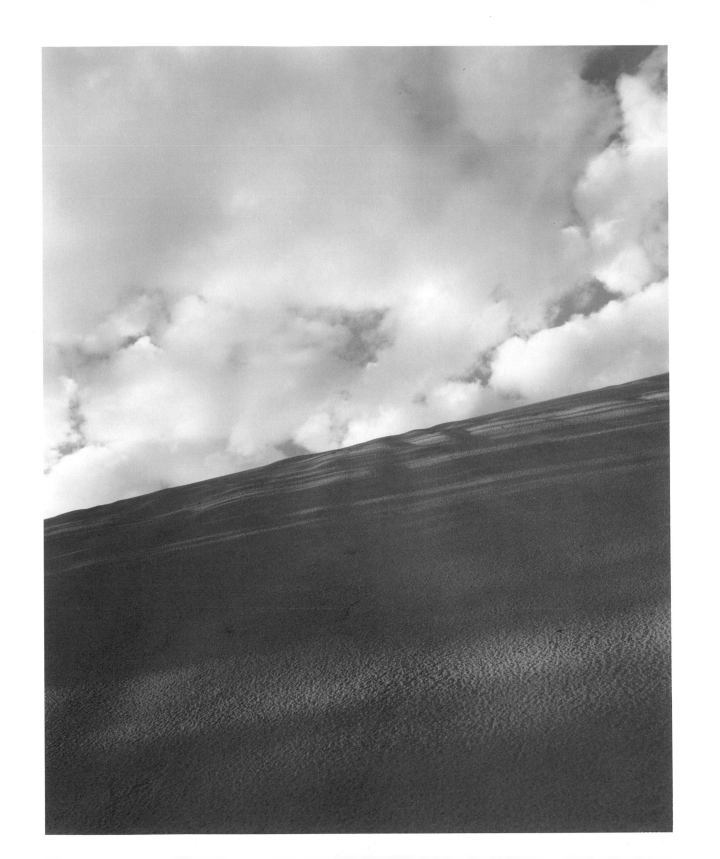

PLATE 36 JUSTINE, PROVINCETOWN, 1977 (cat. 88)

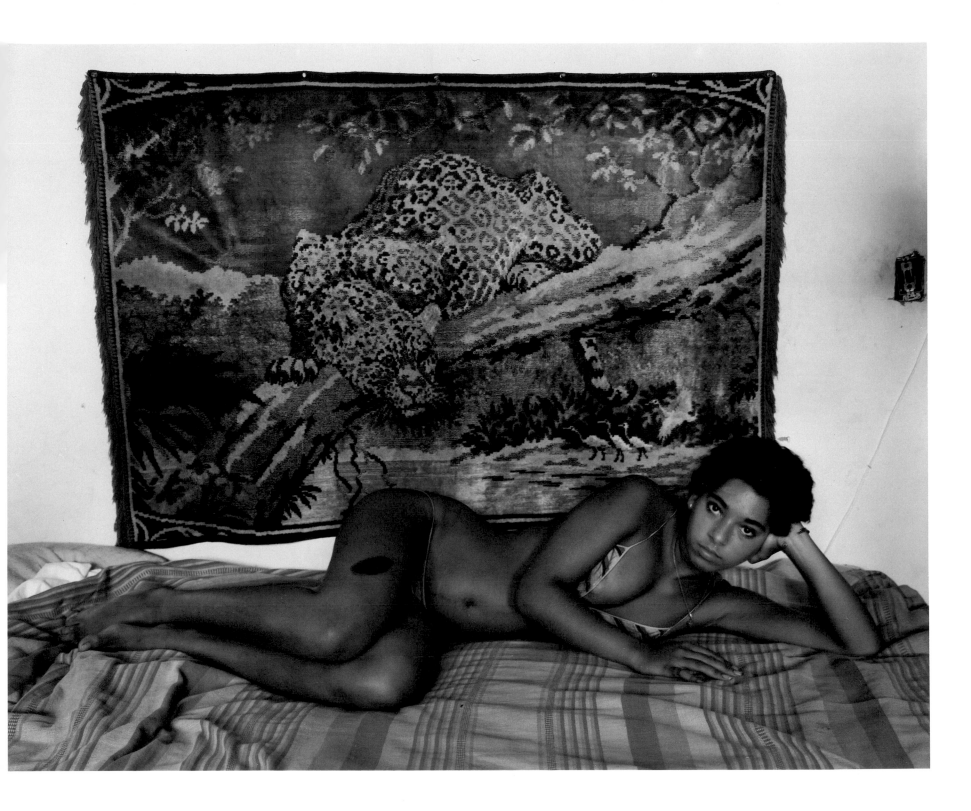

PLATE 37 PROVINCETOWN, 1977 (cat.53)

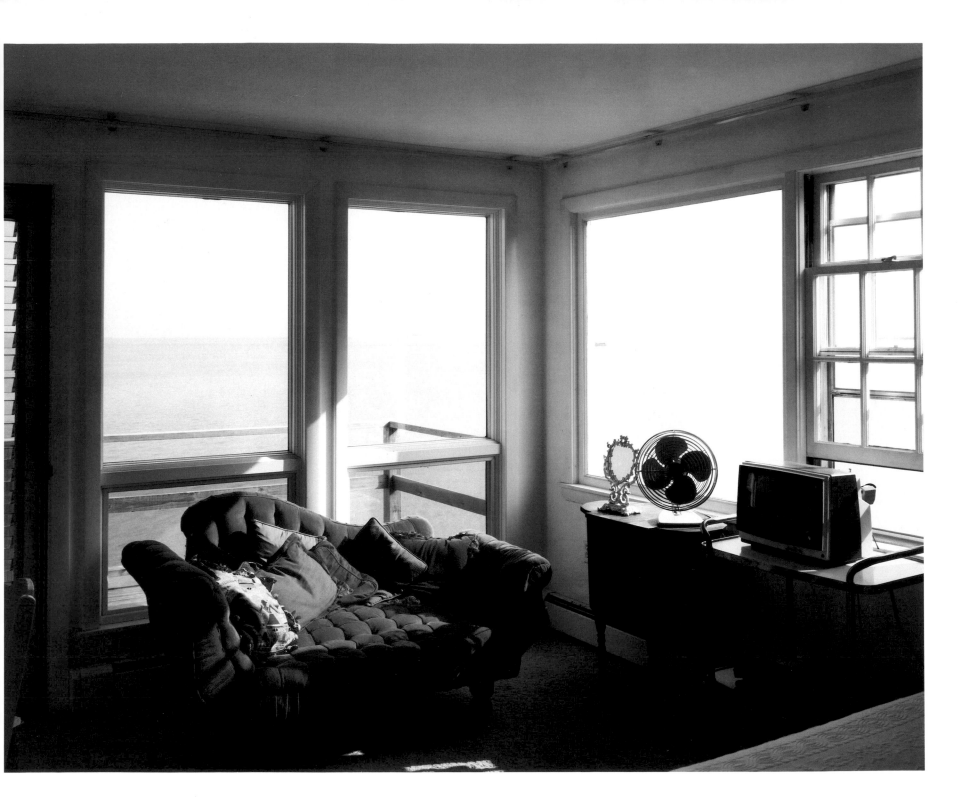

PLATE 38 PROVINCETOWN, 1977 (cat. 78)

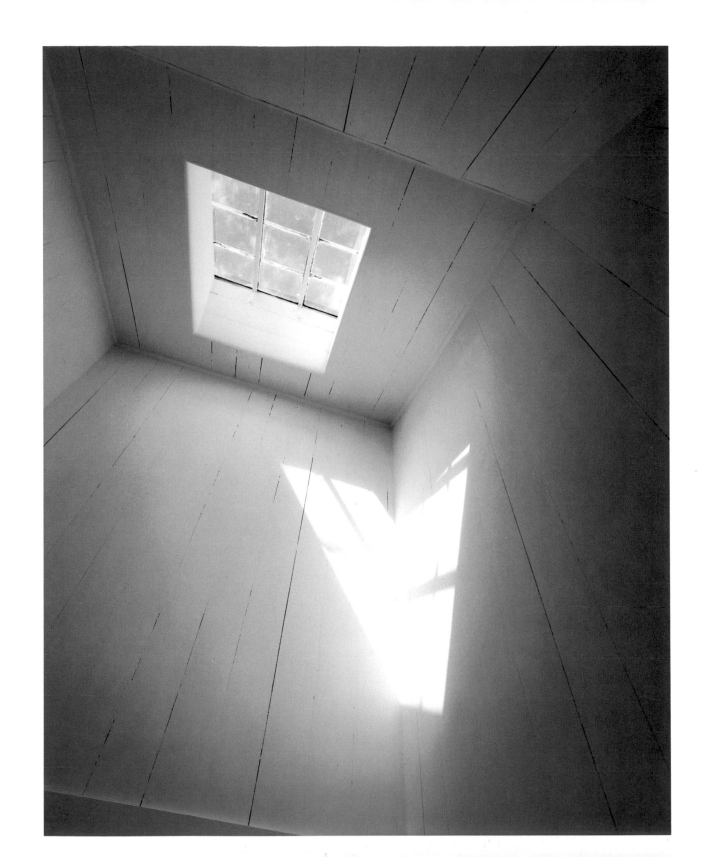

PLATE 39 PROVINCETOWN, 1977 (cat.77)

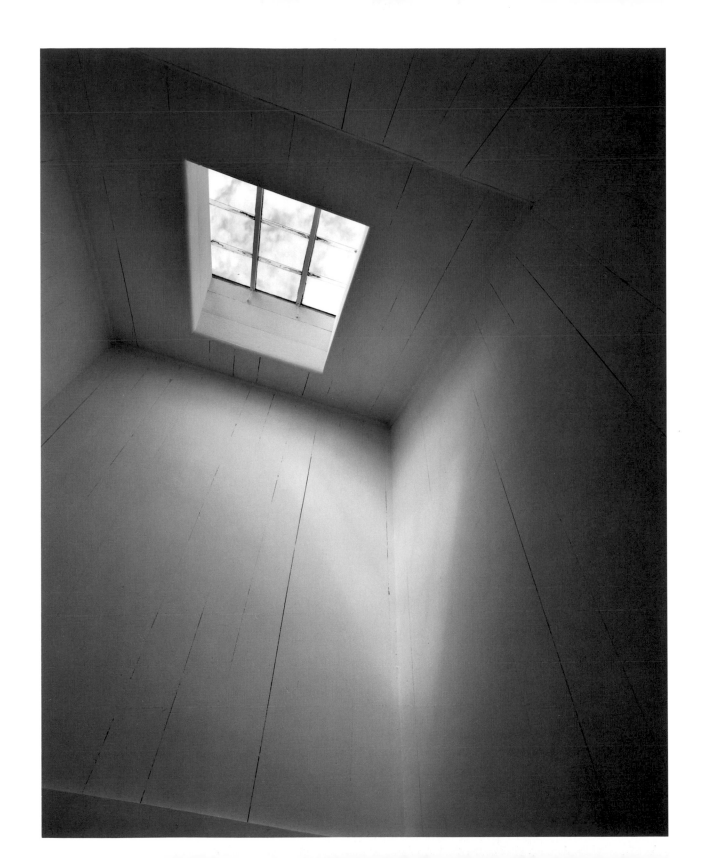

PLATE 40 LONGNOOK BEACH, TRURO, 1976 (cat.35)

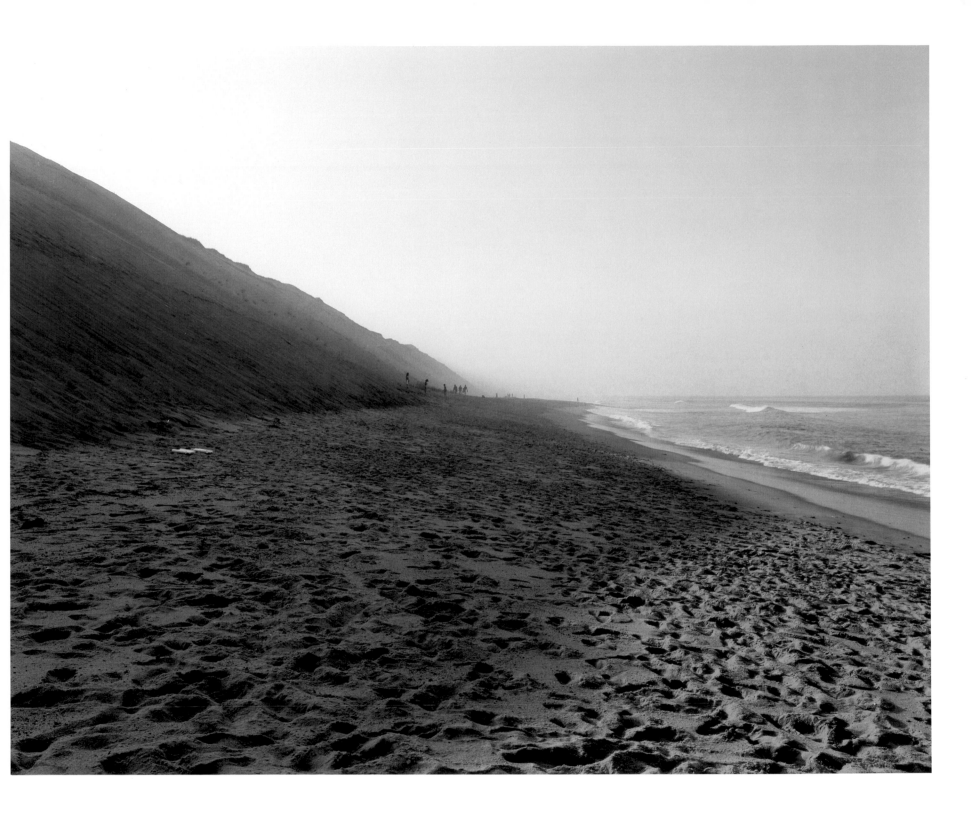

CHRONOLOGY

1938	Born in New York City.
1955	At Ohio State University, studied painting and medical drawing. Painted loose, drew tight. Always liked the difference between the two.
1959	Back in New York. Worked in advertising as an art director-designer.
1962	Began photographing, stopped everything else. First photographs in the form of color slides.
1963	Felt the need to make prints. Began shooting black and white. Photograph included in Museum of Modern Art show "The Photographer's Eye." Married Vivian Bower.
1964	Traveled around United States photographing for three months.
1966–67	Spent year traveling in Europe.
1968	Son Sasha born. One-man exhibition "My European Trip: Photographs from a Moving Car" at Museum of Modern Art.
1970	Received Guggenheim Fellowship to travel in United States and photograph what "leisure time" looks like. Continued this work through 1974. Black-and-white and color photographs brought together in a book called "Still Going" (unpublished).
1970	Exhibition: "10 Americans" at U.S. Pavilion, Expo 70 Japan.
1971	Exhibition: "New American Photography," worldwide touring show organized by Museum of Modern Art. Daughter Ariel born. Began teaching color photography at Cooper Union.
1973	Color side of work becomes more important. Begin printing in color. Subject on streets changes from incident to overall field photograph. Architecture, light, space have new interest. Photograph published in *Looking at Photographs: One Hundred Pictures from the Collection of the Museum of Modern Art,* by John Szarkowski.
1976	Received from the New York State Council on the Arts a Creative Artists' Public Service Program grant. Bought 8″ × 10″ camera. Began work on Cape Cod.
1977	The St. Louis Art Museum commissions project "St. Louis and the Arch," assisted by a grant to the museum from the National Endowment for the Arts.
1978	Received a Photographers' Fellowship from the National Endowment for the Arts.
1978–80	Received, jointly with Colin Westerbeck, Jr., grant from the National Endowment for the Humanities to study and write a book on the history of street photography.
1978–79	Received Guggenheim Fellowship. Work in color on the streets with the small camera (35 mm).
1978	Exhibition: "Mirrors and Windows: American Photography since 1960," at the Museum of Modern Art.
1978	A.T. & T. Project: 8″ × 10″ color photographs of the Empire State Building.

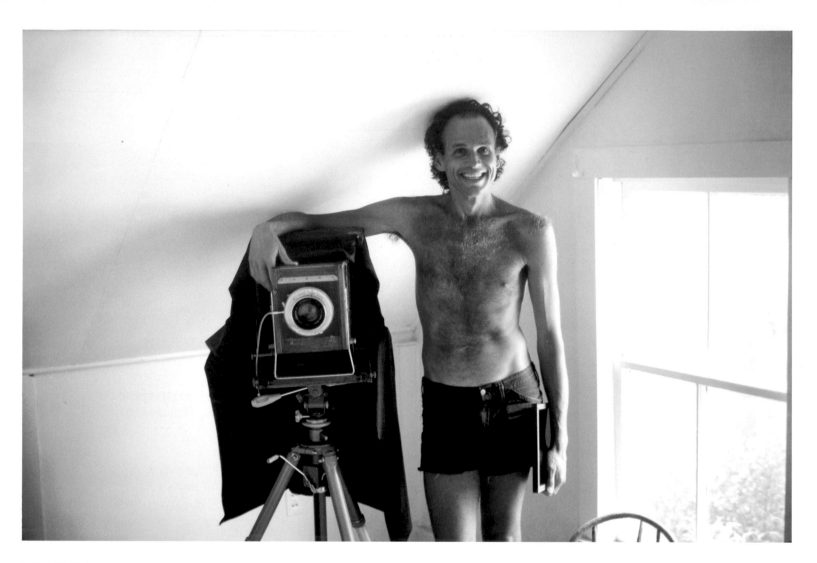

JOEL MEYEROWITZ, 1978. Photograph by Max Kozloff

A NOTE ON TECHNIQUE

For the last two years I have been using a vintage 8″ × 10″ Deardorff field view camera. Like me, it was made in 1938, but it hasn't changed much. It still presents a shining mahogany face, and its brass and leather reflect the history of its outings like the medals and decorations on the chest of an old veteran. As for me, I'm beginning to feel the effects of carrying around 45 pounds of equipment. Still, it gives me almost as great a pleasure looking at it as looking through it.

What I see there, in the dark, under the cloth, is an image that is upside down and backwards, confusing at first but more and more satisfying and familiar as I get used to it. Astronauts experience similar orientation problems in space. They establish a "local vertical"; I use the horizon. I also use a wide-field Ektar lens of 250 mm called a "10 inch." Its sweep takes in less than our vision but has the "feel" of how we see. This lens puts me in a relationship to objects in space that is very personal. It doesn't magnify them or push them radically out of reach. When I stop in front of something, what I see in the camera is what I felt. No more or less. It seems to me a perfect tool.

The film I use is called Vericolor II Type L (long-exposure) negative film. Its ASA (film speed) is 80, and although it is balanced for tungsten and supposed to be filtered in daylight, I don't do that. I'd rather shoot it straight and correct it in the darkroom. Under certain conditions the film appears to be almost a universal film, seeing both daylight and artificial light in proper relationship. This property has led me to make many of the photographs in this body of work. The exposures here are often between 4 and 10 minutes at f 90, while the average daytime exposure is ½ second at f 90. It's not a film for horse races.

The prints are made on Ektacolor 74 resin-coated paper. This is a plastic sandwich with dyes in the middle. It is currently the best material to respond to the information stored on the negative. The prints are made in my darkroom, using two steps of chemistry (developer and bleach fix) washed in water, and then are air dried. The whole process takes about five minutes. However, to make a print that is subtle, luminous, and true to both memory and fact often takes many hours and many printings.

J. M.

CHECKLIST

All the photographs were taken on Cape Cod.
The checklist is arranged in the order in which the photographs were taken.
Each image is approximately 8 x 10 inches.
*indicates photograph reproduced in color.

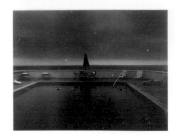

7. Truro, 1976*

11. Wilson Cottage, Wellfleet, 1976*

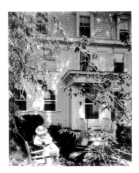

15. Provincetown, 1976*

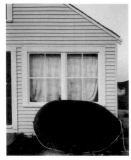

1. Hartwig House, Truro, 1976*

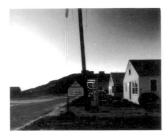

4. Truro, 1976*

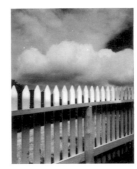

8. Truro, 1976*

12. Provincetown, 1976

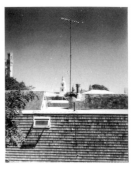

16. Provincetown, 1976

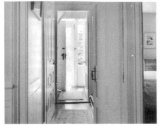

2. Truro, 1976*

5. Wellfleet, 1976

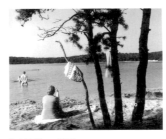

9. Wellfleet, 1976

13. Provincetown, 1976

17. Provincetown, 1976

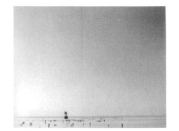

3. Cold Storage Beach, Truro, 1976*

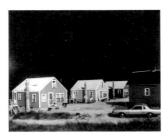

6. Truro, 1976

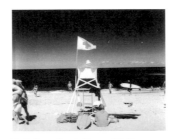

10. Ballston Beach, Truro, 1976*

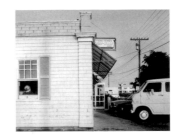

14. Provincetown, 1976*

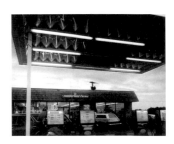

18. Provincetown, 1976*

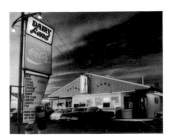

19. Provincetown, 1976*

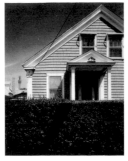

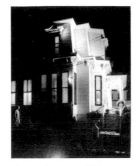

23. Provincetown, 1976

27. Provincetown, 1976

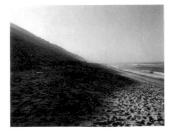

31. Provincetown, 1976

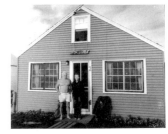

35. Longnook Beach, Truro, 1976*

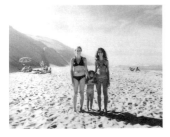

20. Elizabeth, Ariel, and Vivian,
Longnook Beach, 1976

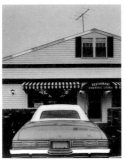

24. Provincetown, 1976

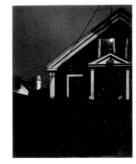

28. Provincetown, 1976

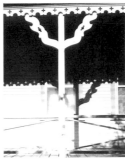

32. Provincetown, 1976

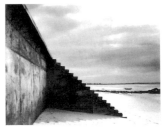

36. The Caldwells, Truro, 1976

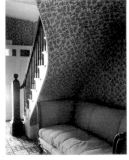

21. "Flying" Stairway, Provincetown, 1976*

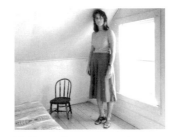

25. Hayden, Provincetown, 1976

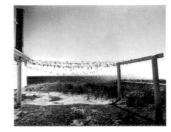

29. Provincetown, 1976*

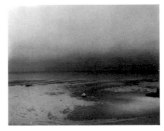

33. Bay/Sky, Provincetown, 1976*

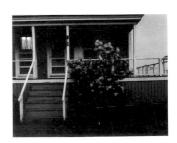

37. Provincetown, 1977

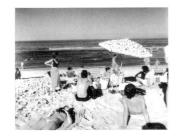

22. Ballston Beach, Truro, 1976*

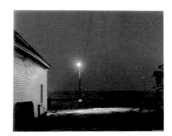

26. Provincetown, 1976

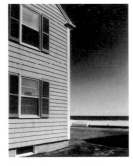

30. Provincetown, 1976*

34. Vivian, 1976*

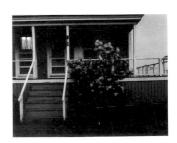

38. Provincetown, 1977

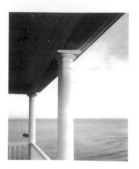

39. Porch, Provincetown, 1977*

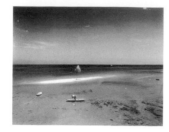

43. Bay/Sky, Provincetown, 1977*

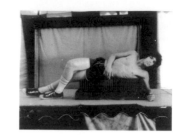

47. Porch, Provincetown, 1977

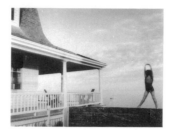

51. Tom Laurita, Provincetown, 1977

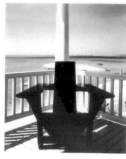

55. Porch, Provincetown, 1977

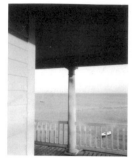

40. Porch, Provincetown, 1977

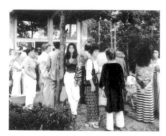

44. Cocktail Party, Wellfleet, 1977*

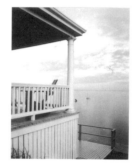

48. Porch, Provincetown, 1977*

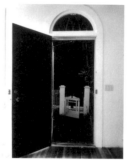

52. Provincetown, 1977

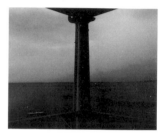

56. Porch, Provincetown, 1977*

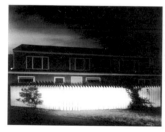

41. Provincetown, 1977

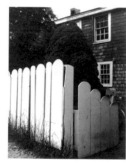

45. Provincetown, 1977

49. Provincetown, 1977

53. Provincetown, 1977*

57. Porch, Provincetown, 1977*

42. Bay/Sky, Provincetown, 1977

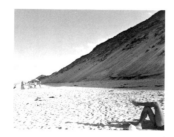

46. Longnook Beach, Truro, 1977

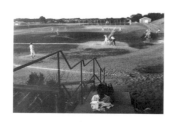

50. Provincetown, 1977*

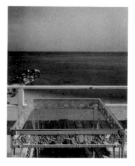

54. Provincetown, 1977*

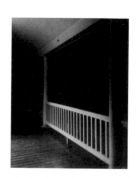

58. Porch, Provincetown, 1977

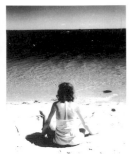

59. Provincetown, 1977

63. Red Interior, Provincetown, 1977*

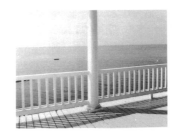

67. Bay/Sky, Provincetown, 1977

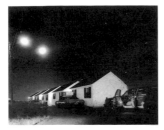

71. Porch, Provincetown, 1977

75. Ballston Beach, Truro, 1977

60. Provincetown, 1977

64. Provincetown, 1977

68. Provincetown, 1977

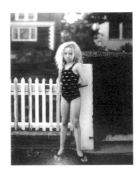

72. Provincetown, 1977*

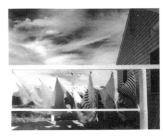

76. Provincetown, 1977*

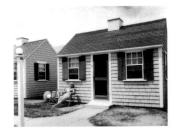

61. Provincetown, 1977

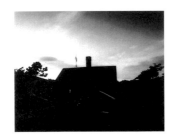

65. Provincetown, 1977

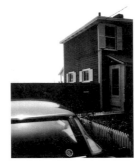

69. Provincetown, 1977

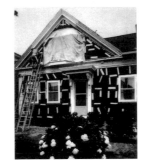

73. Provincetown, 1977

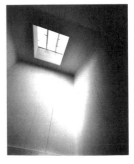

77. Provincetown, 1977*

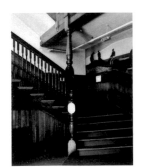

62. Provincetown, 1977

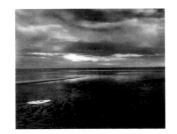

66. Bay/Sky, Provincetown, 1977*

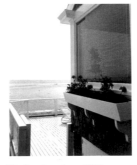

70. Provincetown, 1977*

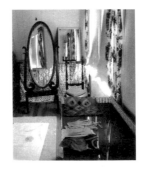

74. Provincetown, 1977*

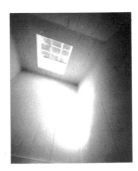

78. Provincetown, 1977*

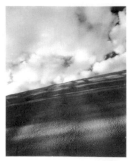

79. Provincetown, 1977*

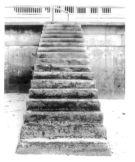

83. Provincetown, 1977

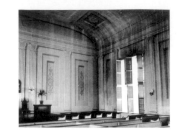

87. Porch, Provincetown, 1977*

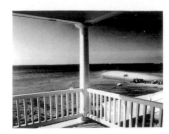

91. Trompe-l'oeil Interior,
Provincetown, 1977*

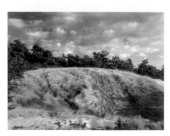

95. Truro, 1978

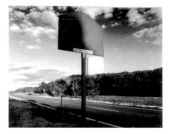

80. Provincetown, 1977

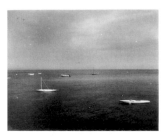

84. Bay/Sky, Provincetown, 1977*

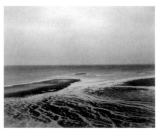

88. Justine, Provincetown, 1977*

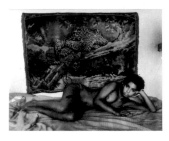

92. Bay/Sky, Provincetown, 1977

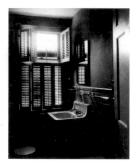

81. Truro, 1977

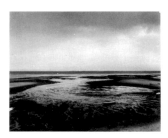

85. Bay/Sky, Provincetown, 1977

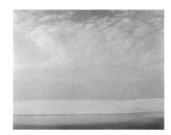

89. Bay/Sky, Provincetown, 1977*

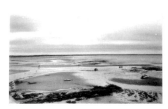

93. Provincetown, 1977*

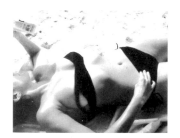

82. Truro, 1977

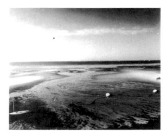

86. Bay/Sky, Provincetown, 1977

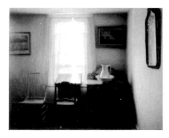

90. Provincetown, 1977

94. Sasha, Provincetown, 1977